NORTHWESTERN PACIFIC

RAILROAD

To

Samantha Miss Jane

Ted Codoni

2013

NORTHWESTERN
PACIFIC
RAILROAD

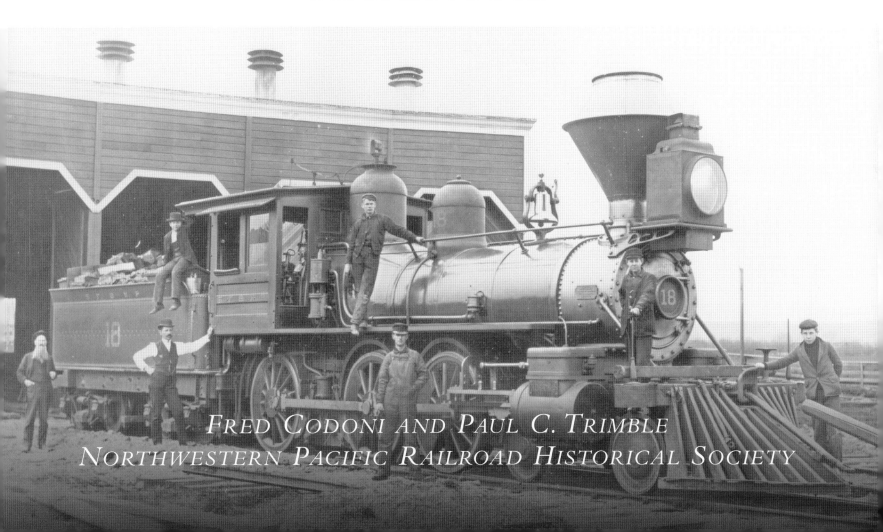

Fred Codoni and Paul C. Trimble
Northwestern Pacific Railroad Historical Society

Published by Arcadia Publishing
Charleston SC, Chicago IL, Portsmouth NH, San Francisco CA

Printed in the United States of America

Library of Congress Catalog Card Number: 2005938414

For all general information contact Arcadia Publishing at:
Telephone 843-853-2070
Fax 843-853-0044
E-mail sales@arcadiapublishing.com
For customer service and orders:
Toll-Free 1-888-313-2665

Visit us on the Internet at www.arcadiapublishing.com

To my wife, Denyce, whose faithful support inspires my work.

—Fred Codoni

This is dedicated to my granddaughter, Grace Maryfrances Mackechnie.

—Paul C. Trimble

CONTENTS

ACKNOWLEDGMENTS

Any history of the Northwestern Pacific Railroad must rely upon the previously recorded histories of this railroad, and in particular those of the late Fred A. Stindt. Fortunately his voluminous collection has been preserved in the Hogarty Library of the Northwestern Pacific Railroad Historical Society, thanks to the generosity of his widow, Jane Stindt.

Acknowledgments are due to those who used their cameras to record rail history and to those who have seen to it that those works were not destroyed or displaced. Unfortunately, many photographs cannot be accurately credited, but to all who clicked their cameras to eventually make this book possible, thanks.

Acknowledgment must be made to those members of the NWPRRHS who have given tirelessly and unselfishly to arrange and catalogue the many collections in the Hogarty Library.

Special thanks are due to NWPRRHS secretary Gus Campagna, who gave so generously of his time and knowledge of the Hogarty Library. Gus was our combination librarian, researcher, and "go to" man when we needed a particular view.

Thanks are due to our editor, Hannah Clayborn. Her knowledge of history and her understanding of the importance of railroad history in the North Coast region of California provided the impetus for this book.

A railroad in and of itself is little more than real estate, hardware, and machinery. Without its engineers, firemen, brakemen, conductors, switchmen, clerks, dispatchers, trainmasters, shopmen, track repair crews, electricians, paymasters, and others, no railroad can function. We therefore acknowledge all NWP employees and managers, past and present, who made the railroad work.

Lastly, we would be remiss if we failed to acknowledge the faithful supporters of the NWP, who have rescued it from the clutches of disaster so many times that it makes the *Perils of Pauline* look like a dress rehearsal. To all of them, from political figures to shippers to members of the general public, thanks for giving us a subject about which to write.

All royalties from this book will go to the Northwestern Pacific Railroad Historical Society, P.O. Box 667, Santa Rosa, California, 95402-0667.

FOREWORD

Perhaps no other railroad in the United States packed so much variety into 570 miles of track as did the Northwestern Pacific Railroad.

Consider: standard-gauge, narrow-gauge, steam, diesel-electric, gas-electric, and straight-electric trains carrying passengers, freight, mail, and express and connecting with ferryboats for passengers, railcars, automobiles, and a tugboat. It pioneered electric railroad technology, developed the first cab-forward locomotive, and ran on tracks with two, three, and even four rails. The system was an effective feeder and subsidiary of the largest railroad in the West, yet at the same time had a subsidiary railroad of its own operating interurban passenger and freight services, stern-wheel riverboats, and tug and barge services. Moreover, one of the NWP antecedents was a steam-powered monorail. This railroad did not need camelbacks, Daylights, or Big Boys to be unique!

In the heyday of the NWP, entire trains were dispatched with cargoes of fresh fish or forest products long before the days of bulk unit trains. Commuters rode the NWP ferries from San Francisco to Sausalito and transferred to electric interurbans to bring them to their destinations on a faster timetable than that of the buses which replaced them.

The NWP was a major facilitator of the depletion of much of the redwood forests in Marin and Sonoma Counties, spurring conversions to suburbia and vacation destinations for Bay Area residents. It created the demand for that world-class marvel of engineering known as the Golden Gate Bridge which, in turn, was a major cause of the railroad's demise.

Today most of the NWP remains intact, in public, not private, ownership, and its future is predicated upon providing relief from the highway congestion that sought to replace it. It is hoped that this volume will introduce railfans, as well as anyone with even a casual interest in this form of transportation, to the fascinating story of a railroad that, more than any other institution, has determined the transportation, planning, and living patterns of today's Northern California coastal counties.

All aboard!

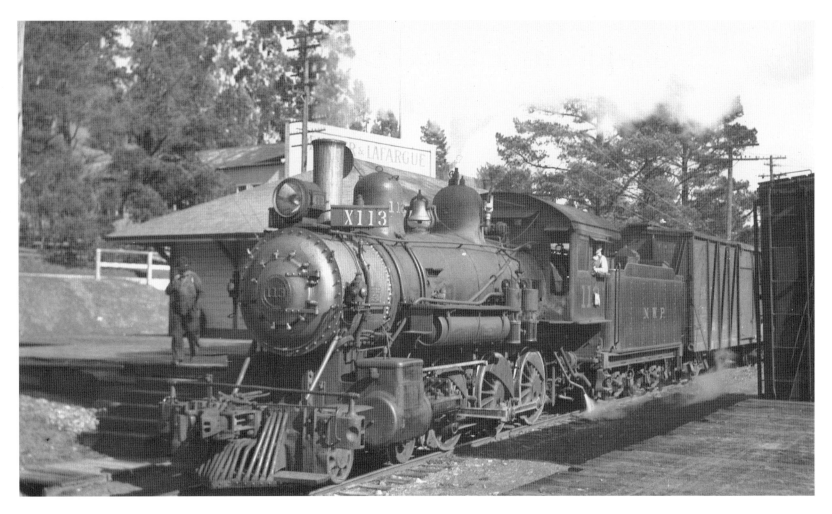

Typical of Northwestern Pacific freight operations, 10-wheeler No. 113 passes the San Anselmo freight house after assembling a freight train in 1935. (Photograph by Warren E. Miller; courtesy Codoni collection.)

OPPOSITE: Locomotive No. 94 was built in 1887 for the slim-gauge South Pacific Coast Railroad, which ran from Alameda to Santa Cruz, coming into the SP orbit in 1886. The SPC became standard gauge in 1906, sending four locomotives to the NWP. SPC No. 20 became NWP No. 144 and was renumbered 94 in 1924, when this photograph was taken. (Photograph by G. M. Best; NWPRRHS Archives.)

THE NARROW GAUGE

The first trackage of what would be the narrow-gauge North Pacific Coast Railroad (NPC) was the standard-gauge (four feet, eight and a half inches) San Rafael & San Quentin Railroad, formed on February 25, 1869, to run between a ferry landing at Point San Quentin (near the prison of the same name) and San Rafael.

The NPC incorporated on December 19, 1871, to build a narrow-gauge (three foot) railroad from Sausalito to Gualala on the Mendocino County coast, although the lines farthest reach was the Russian River and the redwood forests of Sonoma County. On March 11, 1875, the NPC leased the SR&SQ for 43 years, realigned the rails to narrow gauge, junked the rolling stock, and moved its main terminal to San Quentin in June, retaining the Sausalito terminal for special runs. In 1884, Sausalito again became the main terminal for ferries and trains.

The NPC reached Monte Rio in 1876, and the following year, the sawmills at Duncan Mills. In a 1902 reorganization, the NPC became the North Shore Railroad and in 1907, was part of the merger that formed the Northwestern Pacific Railroad (NWP). The NWP added a third rail to accommodate both narrow- and standard-gauge trains, and in 1920, the line between Sausalito and Point Reyes Station became standard gauge only.

Until it was finally abandoned in 1930, the narrow gauge faithfully served farms, lumber mills, mines, and passengers of the Russian River region.

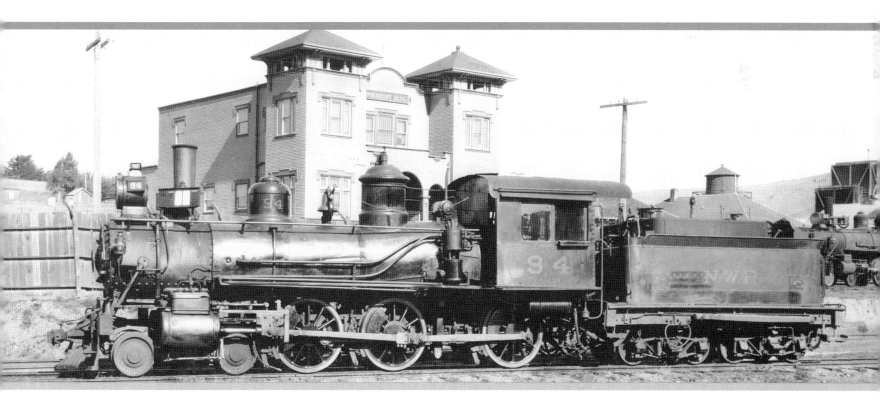

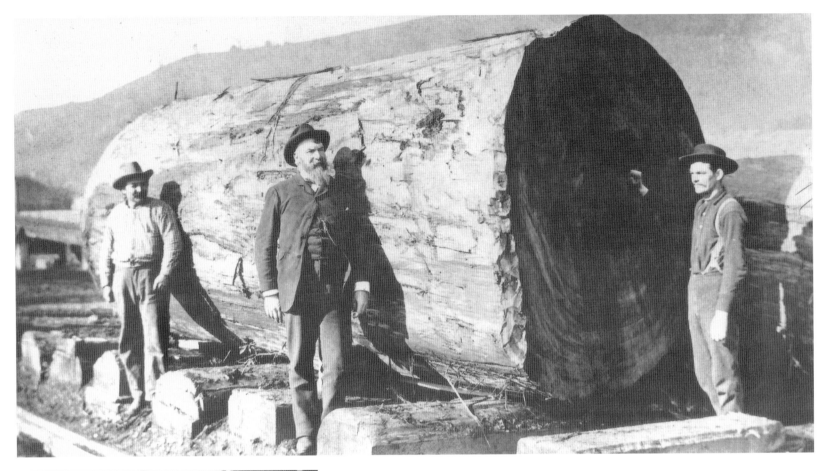

It would be impossible today to determine how many of California's coastal redwood trees succumbed to the axes and saws of lumbermen, but it remains indisputable that the once abundant forests was the impetus for building the North Pacific Coast Railroad, for only a railroad could have supplied the necessary mechanical power to move the volume of lumber milled from these forest leviathans. (Courtesy NWPRRHS Archives.)

Duncan Mills sawmill, pictured here c. 1890, converted thousands of redwood trees into valuable lumber for California's construction industry as if there were no tomorrow. Tomorrow did come, however, and by 1910, the lumber mills near the Russian River were shut down for good. (Courtesy NWPRRHS Archives.)

In 1894, San Francisco hosted the first of its three world fairs—the California Midwinter Exposition. Since one purpose of a fair is to promote industry and commerce, it was fitting that the Fallon Creamery created this giant cheese to exhibit, shipped via the NPC, of course. (Courtesy NWPRRHS Archives.)

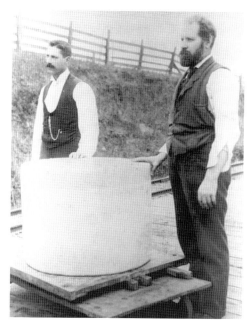

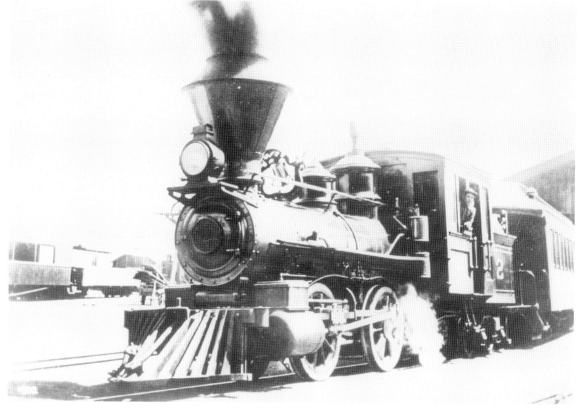

The NPC began at Sausalito, where it met the company-owned ferries from San Francisco. In this photograph, the 2 Spot is leaving Sausalito on the Mill Valley local. One wonders how environmentally conscious Mill Valley would like this wood burner on today's Miller Avenue. (Courtesy Trimble collection.)

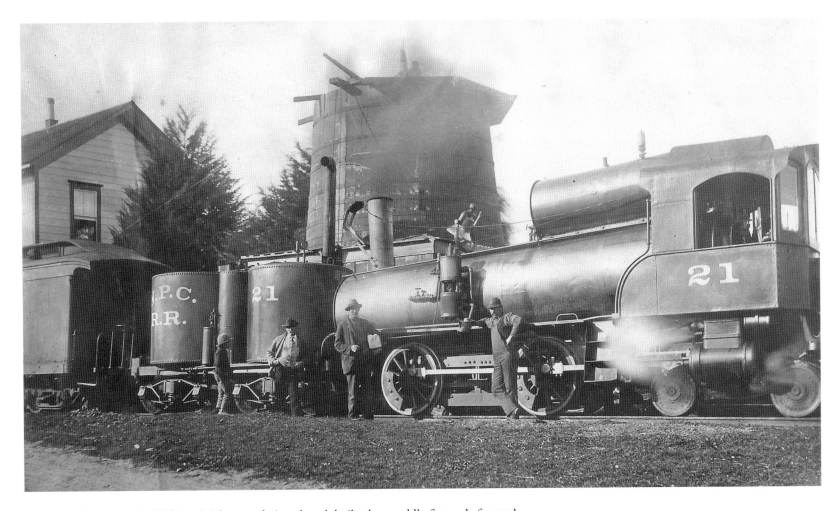

NPC master mechanic William J. Thomas designed and built the world's first cab-forward locomotive, No. 21, the forerunner of the huge cab forwards of the Southern Pacific. While No. 21 served well in her short lifespan, she was an experiment and did not warrant the expensive repair work when the boiler tubes blistered. She was scrapped in 1905. (Courtesy NWPRRHS Archives.)

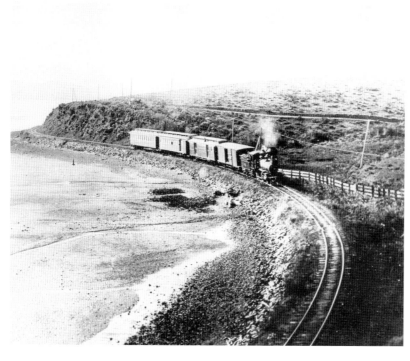

Historian Roy D. Graves photographed a North Shore Railroad train running south above the mudflats of Tomales Bay at Bivalve in 1905 with locomotive No. 4. Bivalve is an aptly named town, for its shellfish industry was a major contributor to the railroad's freight revenues. (Courtesy NWPRRHS Archives.)

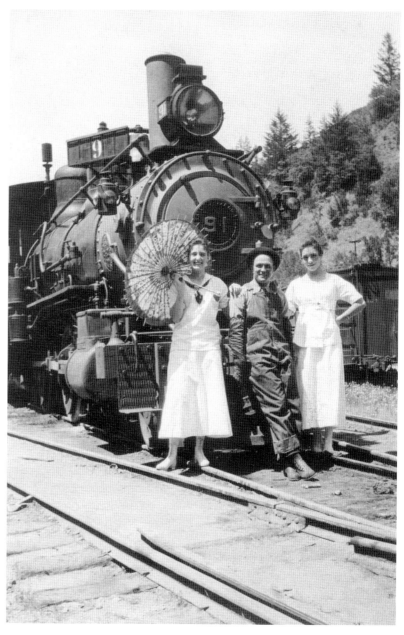

A handsome engineer, two pretty girls, and locomotive No. 91 pose at Cazadero as Train No. 9 waits to depart for Sausalito. (Courtesy Codoni collection.)

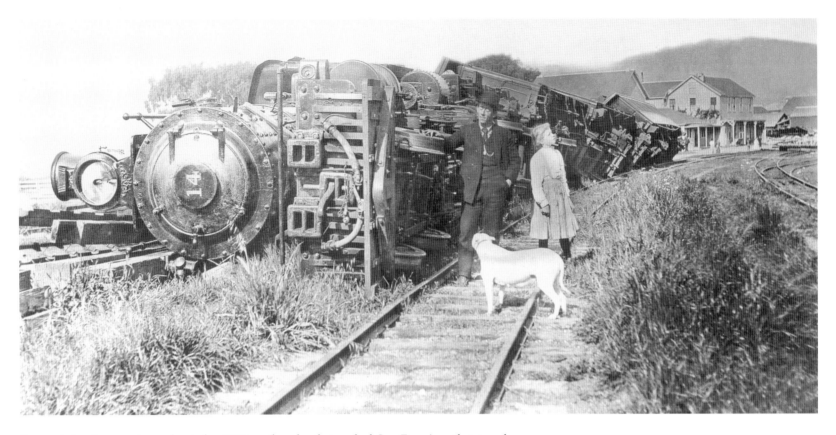

So much has been written about the 1906 earthquake that rocked San Francisco that people are apt to forget that the surrounding regions were also hard hit, as this photograph of NS No. 14 at Point Reyes Station on April 18, 1906, shows. Yes, the train was late that day! (Courtesy NWPRRHS Archives.)

At one time, the town of Marshall on Tomales Bay was called Marshalls, as this postcard view shows. Marshall remains much the same today: a quiet village in western Marin County. (Courtesy NWPRRHS Archives.)

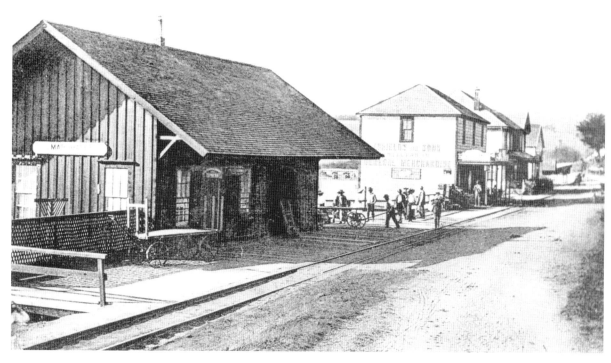

Marshalls, Marin Co., Cal.

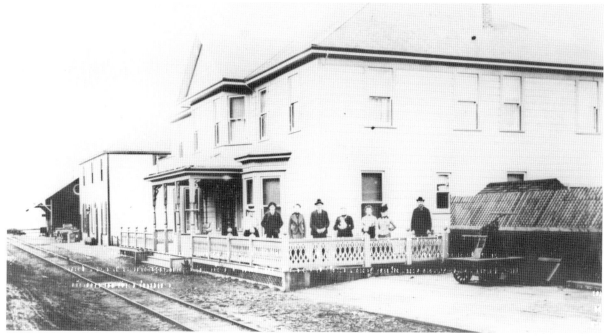

This is Marshall, *c.* 1905. Bordering the North Shore right-of-way are a depot, a store (later to become a tavern), and the North Coast Hotel, which was owned by the Shields family. A railroad brought business to a community in those days. (Courtesy NWPRRHS Archives.)

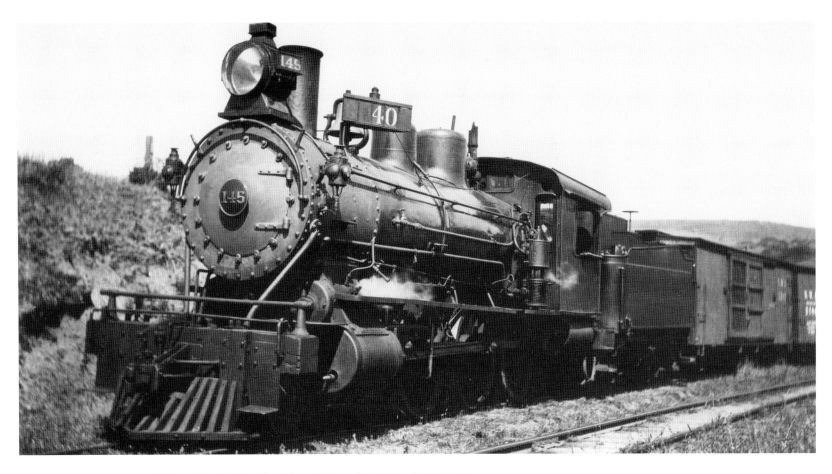

In 1917, Engine No. 145 is pulling Train No. 40 at Marconi. Engine No. 145 began as NPC No. 18 in 1899, then NSRR No. 18, and finally NWP No. 145. Although No. 145 made her last run on August 21, 1929, she was not scrapped until December 1935. (Courtesy NWPRRHS Archives.)

When engine No. 9 wrecked in 1894, ever–resourceful master mechanic Bill Thomas salvaged what he could to build No. 17, pictured here. Hoisting cords of oak to fuel the engines was a man's job, but the locomotive firemen must have welcomed the conversion to oil fuel. (Courtesy NWPRRHS Archives.)

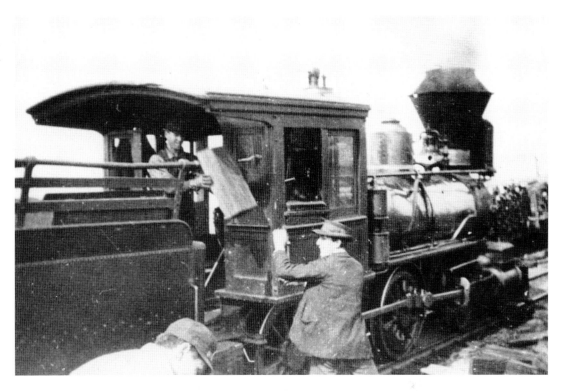

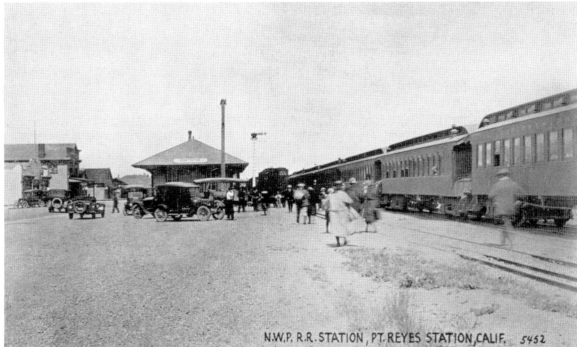

It is train time at Point Reyes Station, and passengers hurry to board this standard-gauge train. Note the three-rail track to accommodate both standard- and narrow-gauge equipment. (Courtesy Codoni collection.)

17

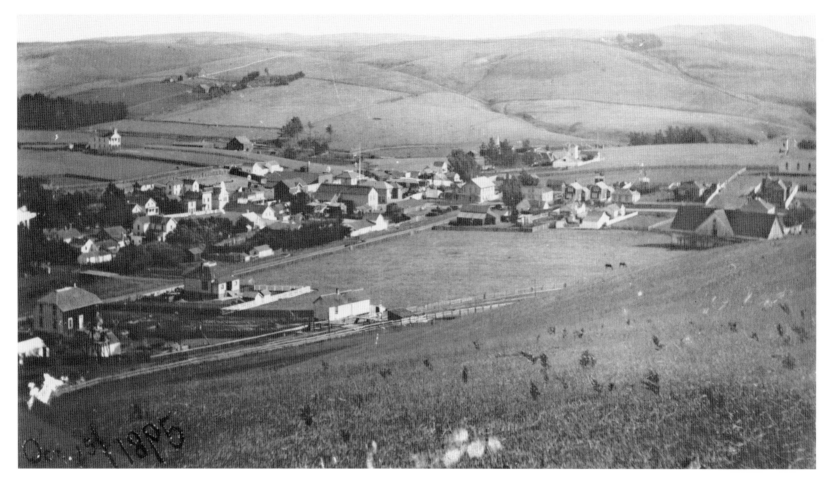

In 1850, the town of Tomales, along the NPC right-of-way, was founded by John Keyes and Alexander Noble. Then, as now, the hills of West Marin provided grazing land for dairy cows. The Fallon Creamery—north of this photograph—once shipped out 30,000 gallons of milk daily on the NWP. (Courtesy NWPRRHS Archives.)

Robert H. McFarland captured this view of a Cazadero-bound train that has stopped along the shoreline of Tomales Bay, c. 1905. A century ago, people wore their Sunday best when riding a train, and that included hats. (Photograph by Robert H. McFarland; courtesy NWPRRHS Archives.)

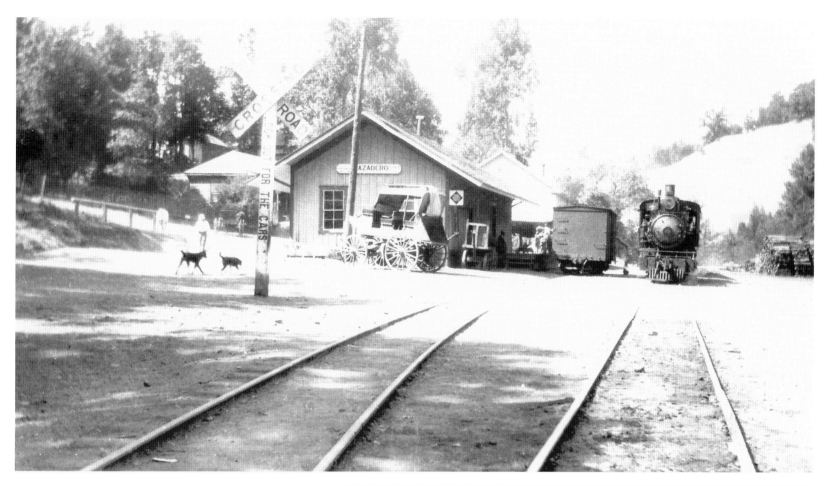

Here is the Cazadero station in 1916. America has yet to enter World War I; there are no cell phones, computers, televisions, drip-dry fabrics, Velcro, digital watches, cameras, polio vaccines, jet planes, flu shots, color photography, or movies with sound. (W. A. Silverthorn, NWPRRHS Archives.)

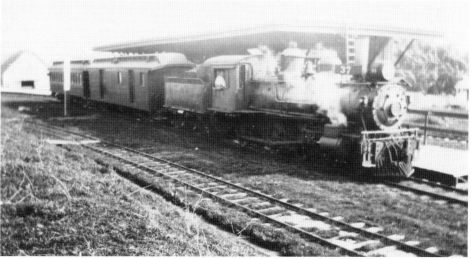

It is March 27, 1930, and paused at the NWP station in Tomales is Train No. 37, a slim gauge that has just two more days of life. The presence of only a single-passenger coach in the consist tells a lot, and the worst days of the Great Depression are still ahead. (Photograph by Fred A. Stindt; courtesy NWPRRHS Archives.)

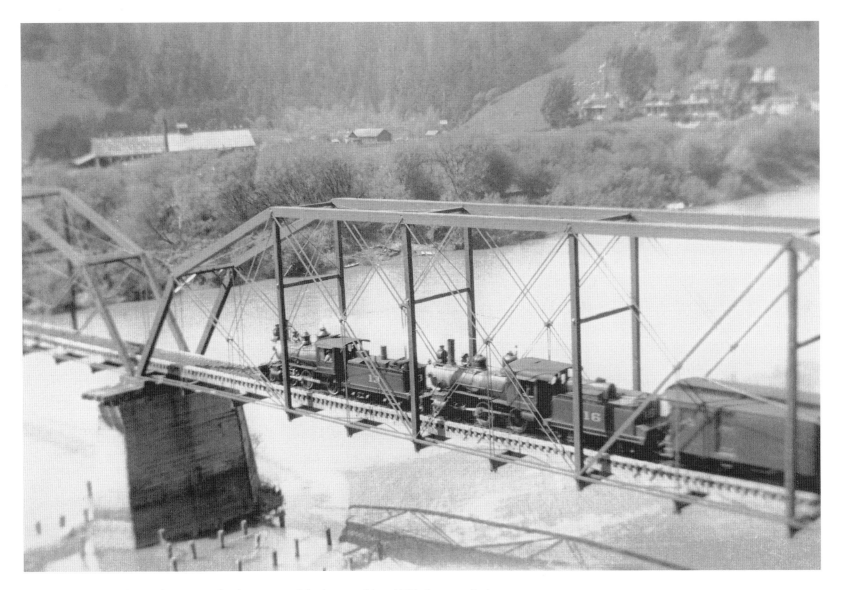

Railroad photographer Robert McFarland was one of the best, as this *c.* 1905 photograph shows. Headed by No. 13, the only mogul on the narrow gauge, and No. 16, a 4-4-0, the train is crossing the Russian River at Duncan Mills. Train No. 13 would be renumbered NWP 195 and then scrapped in 1910, while No. 16 would outlast the narrow gauge, finally going to scrap in 1934. (Photograph by Robert H. McFarland; courtesy NWPRRHS Archives.)

Engineer Bill King (left) and fireman Chick Garcia pose with NSRR No. 31, a 2-8-0 Baldwin Locomotive Works 1885 product. Both hogger and tallowpot were longtime NWP men, while NSRR No. 31—later No. 323—was scrapped in 1915, after only 12 years on the NWP. (Courtesy NWPRRHS Archives.)

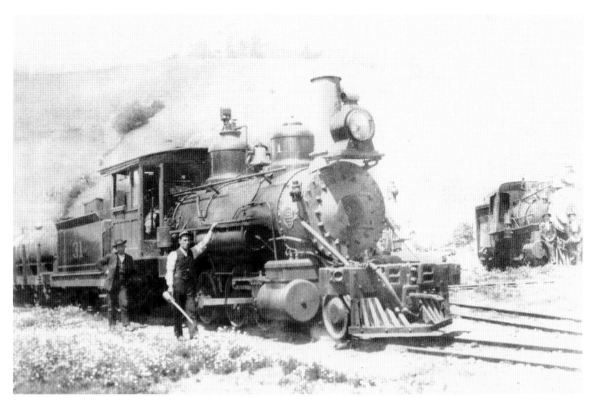

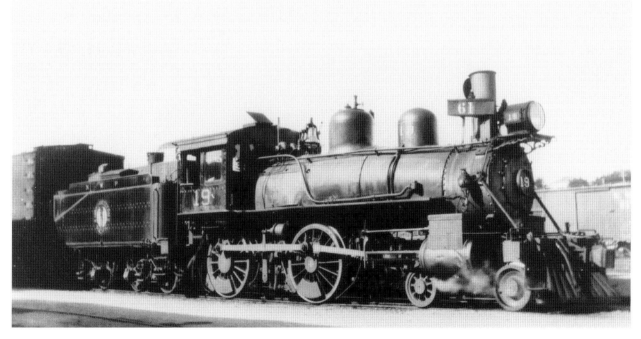

For efficiency, the newly formed NWP began adding a third rail to the narrow gauge in order to handle standard-gauge equipment. On April 6, 1920, the NWP became all standard gauge south of the Point Reyes Station. Here is standard-gauge locomotive No. 19 at Point Reyes Station in 1925. (Courtesy Trimble collection.)

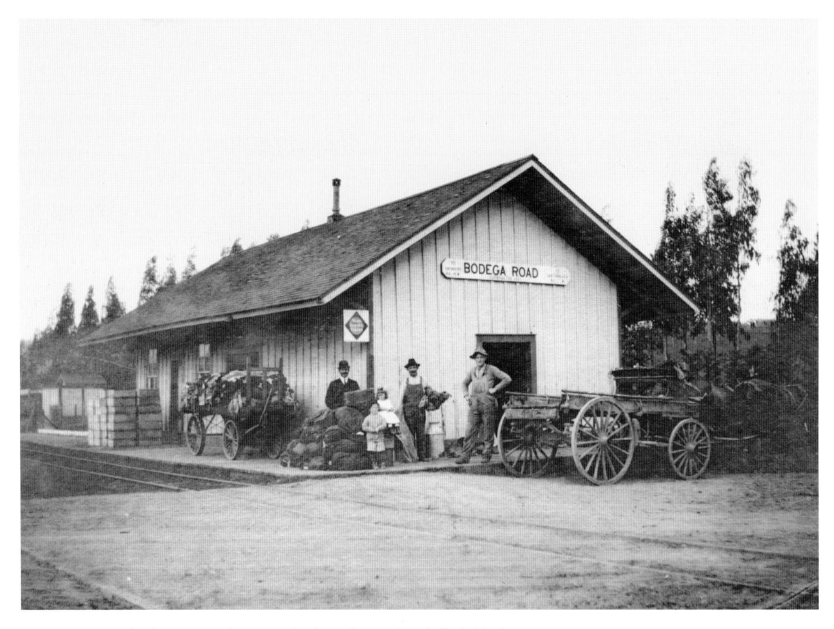

Farmers are waiting for the train at Bodega Road. On the platform, ready to be loaded in the express car, are a ton of butter, a ton of veal, and half a ton of crab. (Courtesy Codoni collection.)

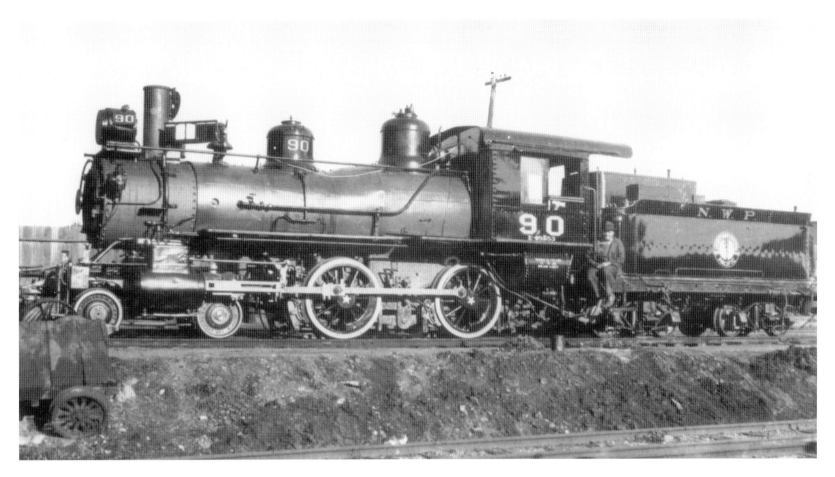

Although abandonment of the narrow gauge is less than two years away, 4-4-0 No. 90 is shining in new paint and has a proud Northwestern Pacific herald painted on her tender. Here, in 1928, she poses with her engineer at Point Reyes Station. (Courtesy Codoni collection.)

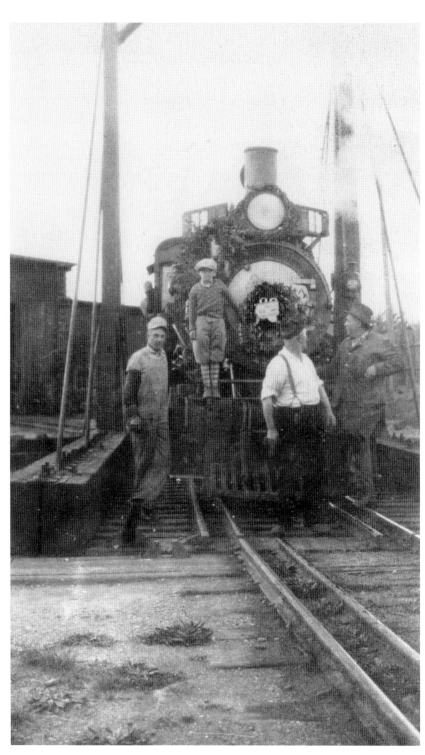

The end of the narrow gauge on the Northwestern Pacific came on March 29, 1930, and Engine No. 90, complete with funeral wreath, was placed on the Point Reyes Station turntable to be sent into the roundhouse. The sign on the front of the train reads, "GONE, BUT NOT FORGOTTEN." How true! (Photograph by Ed Nervo; courtesy NWPRRHS Archives.)

NWP No. 90 sat "dead" in the Point Reyes Station roundhouse, along with Nos. 94 and 95, until October 24, 1934, when they were placed on flatcars and taken to Tiburon for storage and possible sale. The day of the narrow gauge was over, and all three were scrapped in 1935. (Courtesy NWPRRHS Archives.)

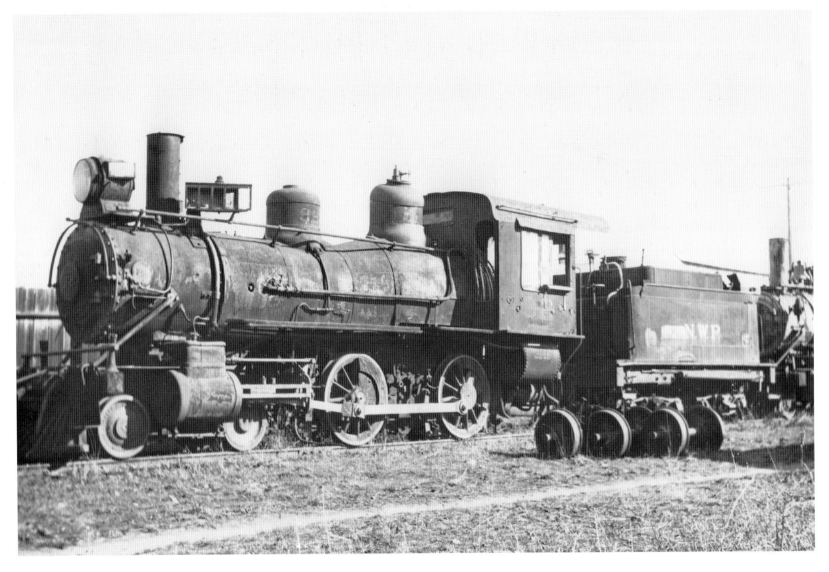

By 1935, outdoor storage had taken its toll on the narrow-gauge locomotives stored at the Point Reyes Station. Once proud 4-4-0 No. 92 sits with her sisters, all but forgotten and rusting away. (Courtesy Codoni collection.)

OPPOSITE: On September 16, 1951, NWP 4-6-0 No. 183 switches the California Western interchange at Willits. (Courtesy Alvon J. Thoman.)

T W O

THE SOUTH END STANDARD GAUGE

Northwestern Pacific's Southern Division encompassed rail service in Marin, Sonoma, and Mendocino Counties as well as the San Francisco ferry. The standard gauge portion extended from terminals at Sausalito (primarily for passenger service) and Tiburon (primarily for freight service) north via San Rafael, Santa Rosa, and Ukiah to Willits.

When the Northwestern Pacific was formed in 1907, the California Northwestern Railway, successor to the San Francisco & North Pacific Railway, operated the line from Tiburon to Willits. The North Shore Railroad, successor to the North Pacific Coast Railroad, ran the line between Sausalito and San Anselmo–San Rafael. From the beginning of the Northwestern Pacific, passenger traffic out of Sausalito was heavy, with trains running to Willits and intermediate points on the San Rafael–Willits main line, as well as to the Russian River via Fulton and the Guerneville Branch and to the Valley of the Moon via Ignacio and the Sonoma Valley Branch. The electric interurban trains shared the main line between Sausalito and San Rafael. Long-distance passenger trains ran between Sausalito and Willits until 1914, when the last spike was driven at Cain Rock on the Northern Division, permitting through service to Eureka and points north.

Main line passenger service was extensive. A 1911 timetable shows 10 steam-powered passenger

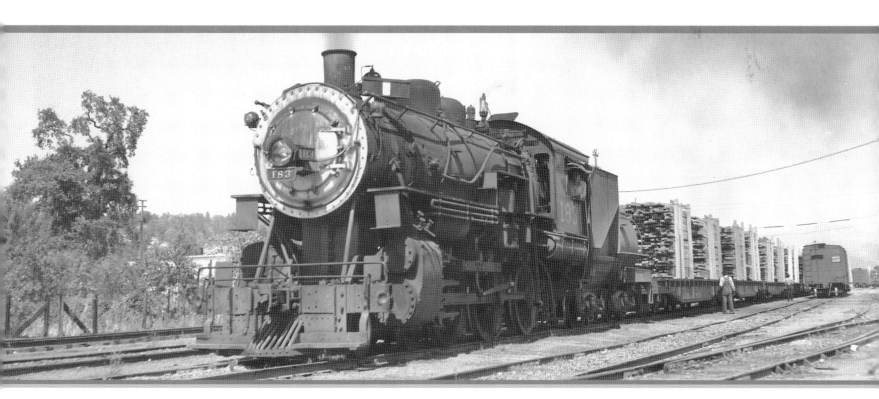

trains each way in and out of Sausalito, plus dozens of electric interurban trains. Steam trains provided frequent service to San Rafael, Petaluma, Santa Rosa, Cloverdale, Ukiah, and Willits. By 1924, summer Sundays saw 14 scheduled steam trains in each direction, often supplemented by second and third sections of regular trains, plus extra passenger trains.

Both passenger and freight traffic increased until the mid-1920s, when the popularity of the automobile and the convenience of freight trucks moving over ever-improving highways began to cut into the railroad's business. By 1935, the passenger business was down to two daily trains each way between Sausalito and Eureka, and the railroad began abandoning the branches that led off the main line. Freight traffic declined because of the Great Depression and did not pick up again until World War II, when the Northwestern Pacific began hauling thousands of carloads of war freight. The housing boom throughout the United States after World War II created a great demand for the forest products of the Redwood Empire, and the Southern Division main line was busy with up to four through freights a day from the Northern Division, each with up to a 100 cars of lumber, plywood, and particleboard for the nation's needs.

Mainline passenger traffic was abandoned on the Southern Division in 1958, but freight traffic continued to be important until the 1970s, when truck competition and depletion of timber on the North Coast resulted in a sharp decline in carloadings.

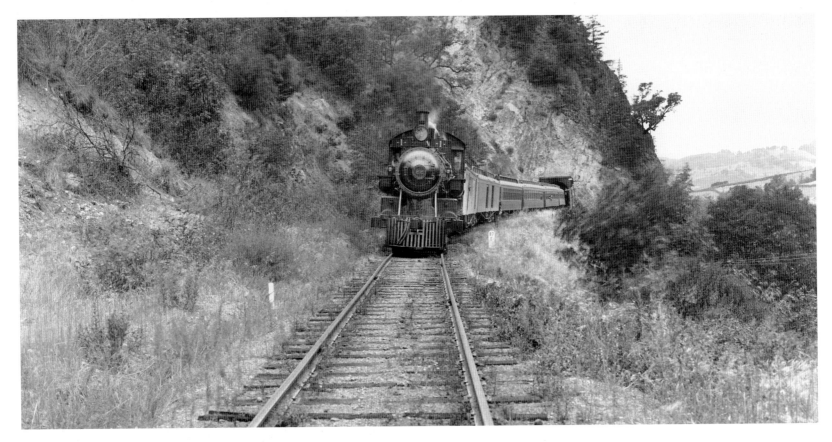

The Northwestern Pacific ran through the Russian River Canyon. About 1915, Train No. 1, led by 4-4-0 No. 22, emerges from tunnel No. 7 at Echo in the Canyon. (Courtesy Codoni collection.)

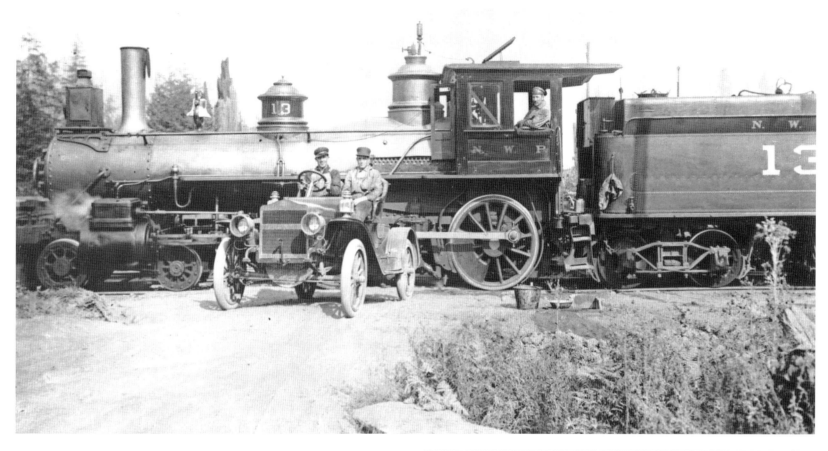

In 1875, NWP 4-4-0 No. 13 was built by Baldwin Locomotive Works for the Atchison, Topeka & Santa Fe as their No. 7 and named *Colorado Springs*. Santa Fe sold it to the California Northwestern, and with the creation of the Northwestern Pacific, it became NWP No. 13. In 1929, the locomotive was scrapped. (Photograph by Fred Stindt; courtesy NWPRRHS Archives.)

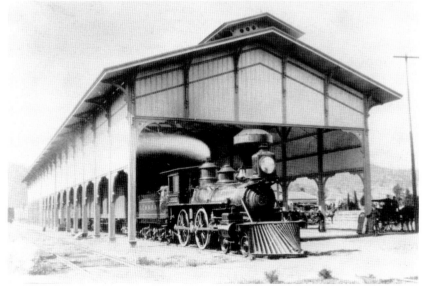

A San Francisco & North Pacific train stops at the San Rafael train shed in the 1890s. The arcade-like structure offered a primitive form of air conditioning in the days when locomotives routinely emitted prodigious quantities of smoke, gases, and steam. Conversely, there was scant protection for waiting passengers from rain, wind, and cold. (Courtesy Codoni collection.)

NO.19 N.W.P. ALONG THE SCENIC NORTHWESTERN PACIFIC.
NEAR RIDGEWOOD.

TURRILL & MILLER PHOTO. S.F

In the earliest days of the Northwestern Pacific Railroad, a short freight train drifts down Ridge Hill from the summit towards Willits. The brakeman is "decorating" (riding the top) the second car from the head end, ready to set the hand brakes should the air brakes be insufficient to stop the train. (Courtesy Codoni collection.)

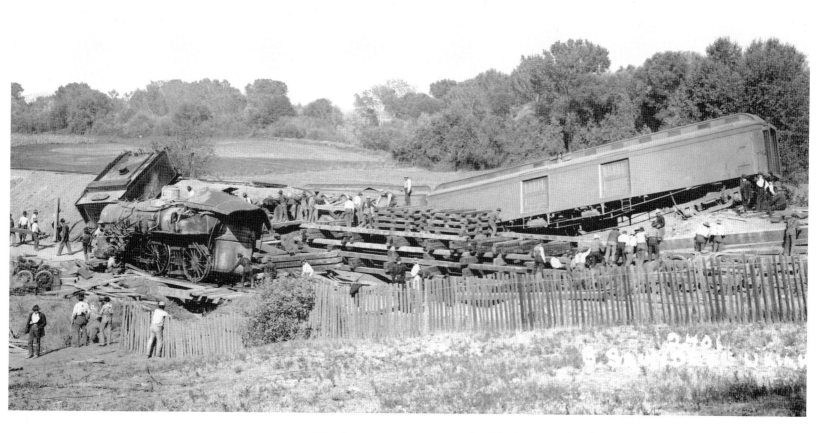

Wrecks were no stranger to the Northwestern Pacific. In October 1911, this passenger train derailed near Hopland. Wrecking crews have righted the locomotive and built cribbing to assist in putting the cars back onto the track. (Courtesy Codoni collection.)

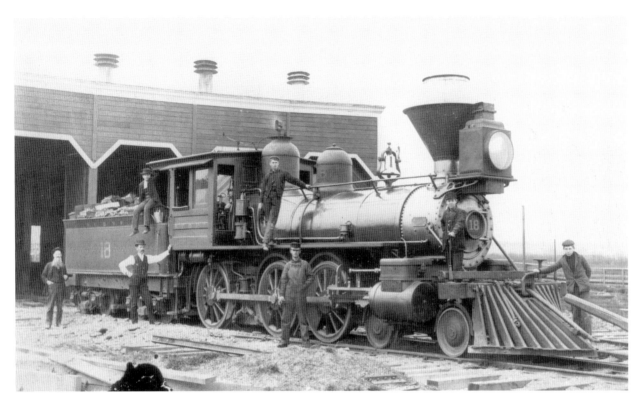

San Francisco & North Pacific 4-6-0 No. 18, pictured at Ukiah, was built by Rogers in 1889 and named *Skaggs*. Later she became NWP No. 101, used on the Santa Rosa-Duncan Mills freight as well as in main line passenger service. (Courtesy Mendocino County Historical Society; Robert J. Lee Collection.)

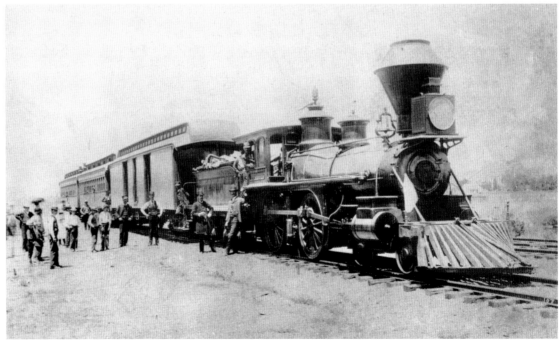

In 1889, SF&NP No. 7, the *Petaluma,* is pictured here heading the first passenger train into Ukiah. (Courtesy Mendocino County Historical Society; Robert J. Lee Collection.)

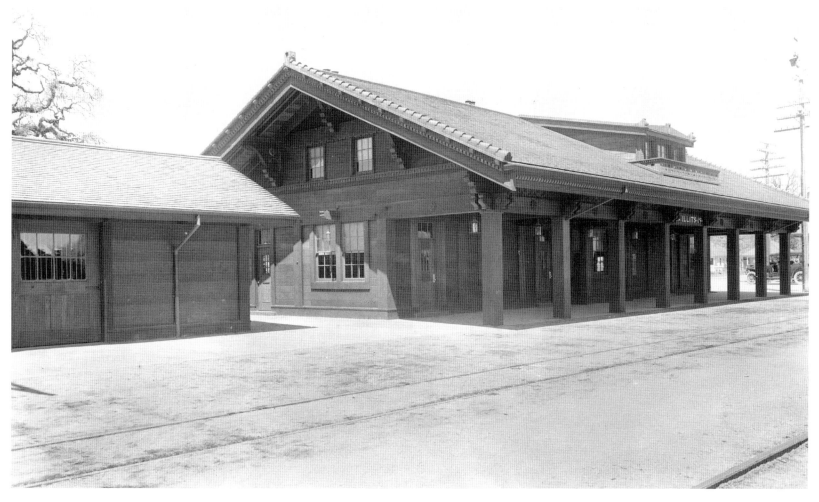

The Willits depot, perhaps the most attractive on the Northwestern Pacific, was constructed entirely of California redwood. The waiting room and offices were adjacent to the track, with a lunchroom at the rear. (Courtesy Codoni collection.)

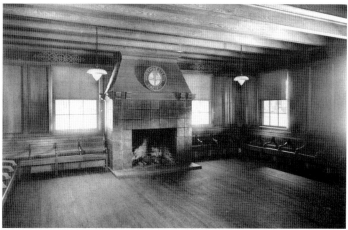

The NWP herald (emblem) decorates the fireplace in the all-redwood Willits depot waiting room. (Courtesy Codoni collection.)

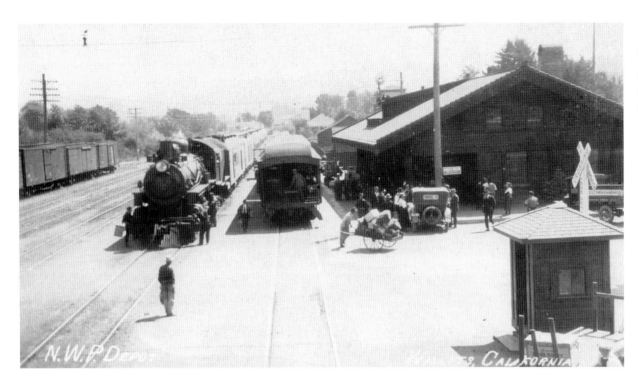

Trains No. 2 (left) and No. 1 meet at Willits. These trains did not have dining facilities and stopped at Willits so passengers could eat in the lunchroom at the rear of the depot. (Courtesy Codoni collection.)

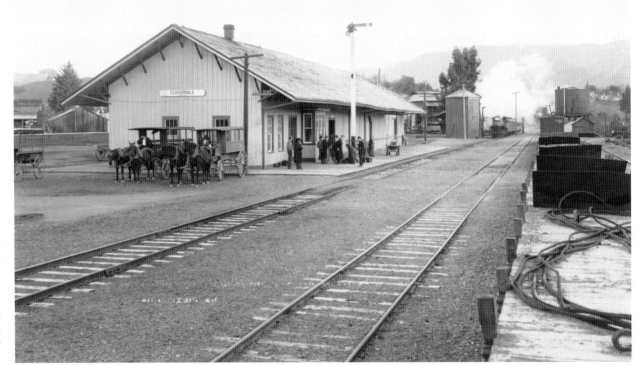

A southbound passenger train approaches Cloverdale around 1910. Passengers are waiting to board, while stagecoaches wait to take detraining passengers to local destinations. The camera's slow shutter speed caused the train to be blurred. (Courtesy Codoni collection.)

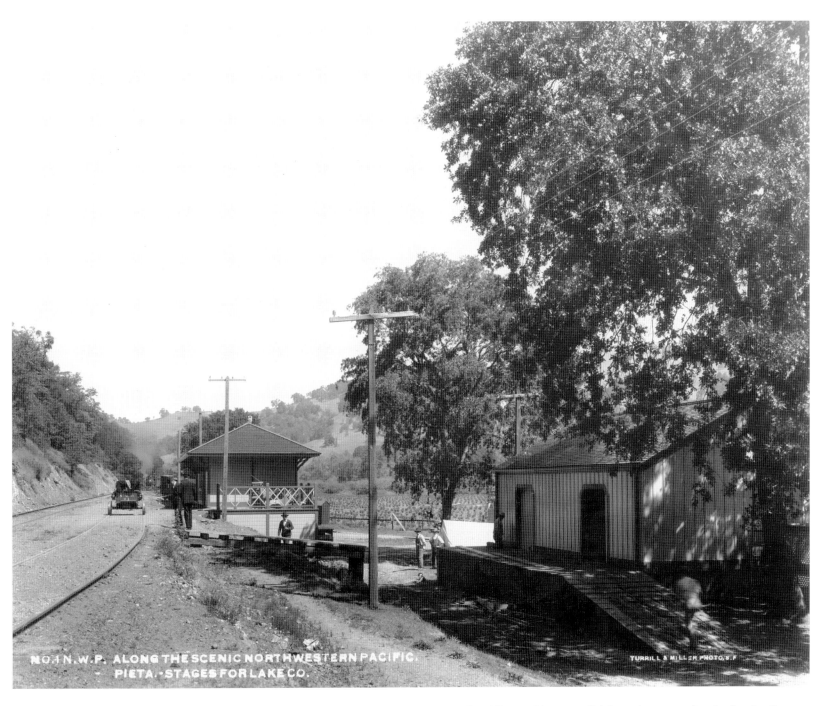

Inspection car No. 01 is in the siding at Pieta as a freight train approaches in the far distance. The two men in suits are probably railroad officials. Passengers transferred here to stages for Lake County. (Courtesy Codoni collection.)

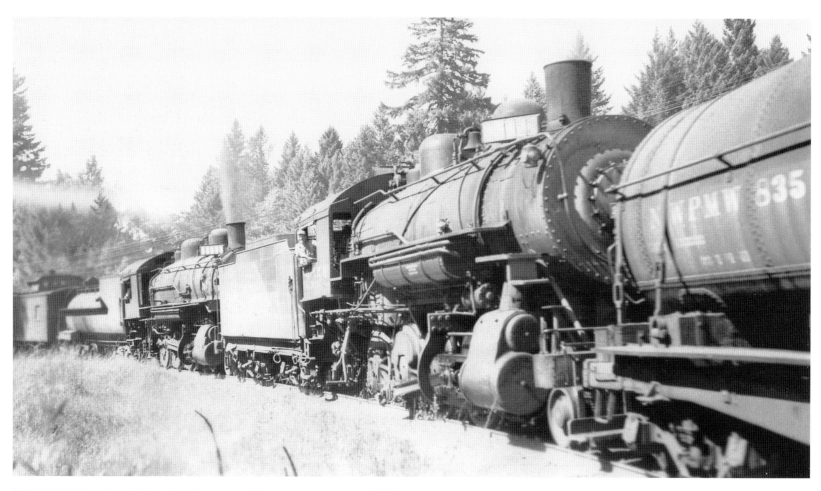

Working hard, these two SP 2-8-0s are cut in ahead of the caboose to boost the train over Ridge Hill. (Courtesy NWPRRHS Archives.)

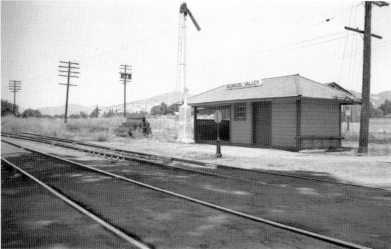

The shed at Redwood Valley could have sheltered passengers if there had been any in this 1950s photograph. It was used mainly used for helper engine crews to communicate with the dispatcher in San Rafael. In steam days, as many as nine helper crews worked between Redwood Valley and Willits assisting trains over Ridge Hill. (Courtesy Codoni collection.)

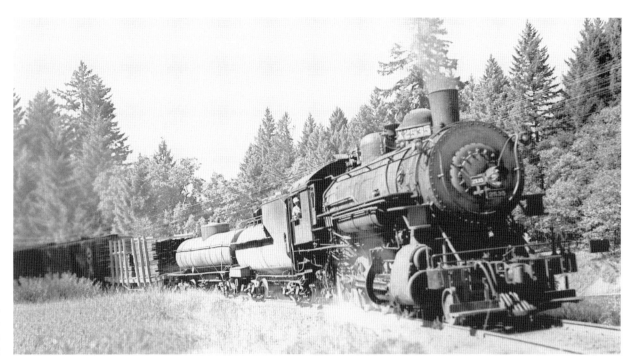

It took four heavy Southern Pacific 2-8-0s to boost this World War II freight train out of Willits and over Ridge Hill—one at the head end, one cut into the middle of the train, and two cut in ahead of the caboose. (Courtesy NWPRRHS Archives).

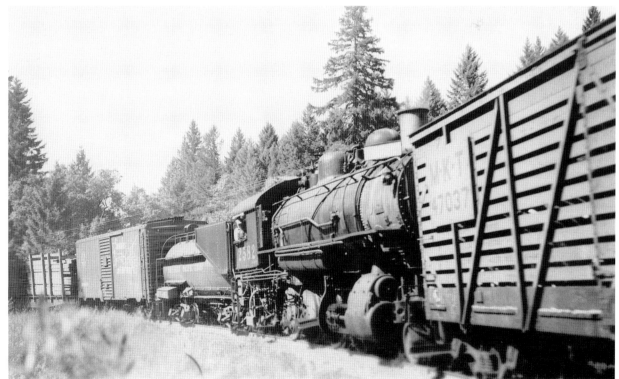

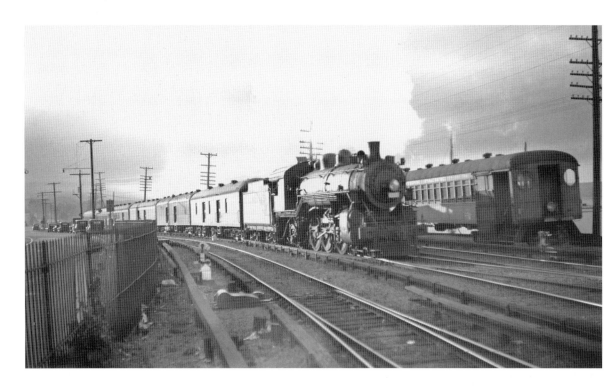

Sausalito was the southern passenger terminus of the Northwestern Pacific. Steam trains shared the trackage with electric interurbans. (Courtesy Codoni collection.)

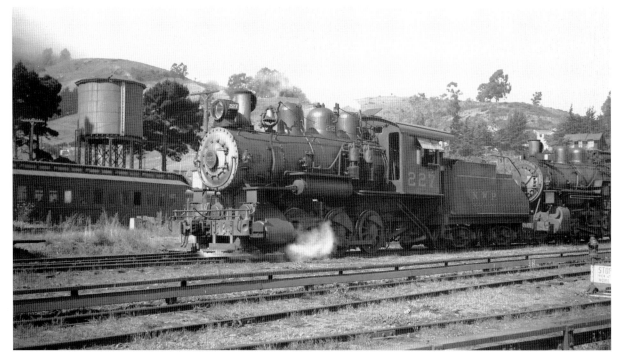

In 1910, the American Locomotive Company built NWP 0-6-0 No. 227. In this photograph, it is being steamed up at Pine (Sausalito) and will soon be switching passenger cars into and out of the Sausalito terminal. (Courtesy Codoni collection.)

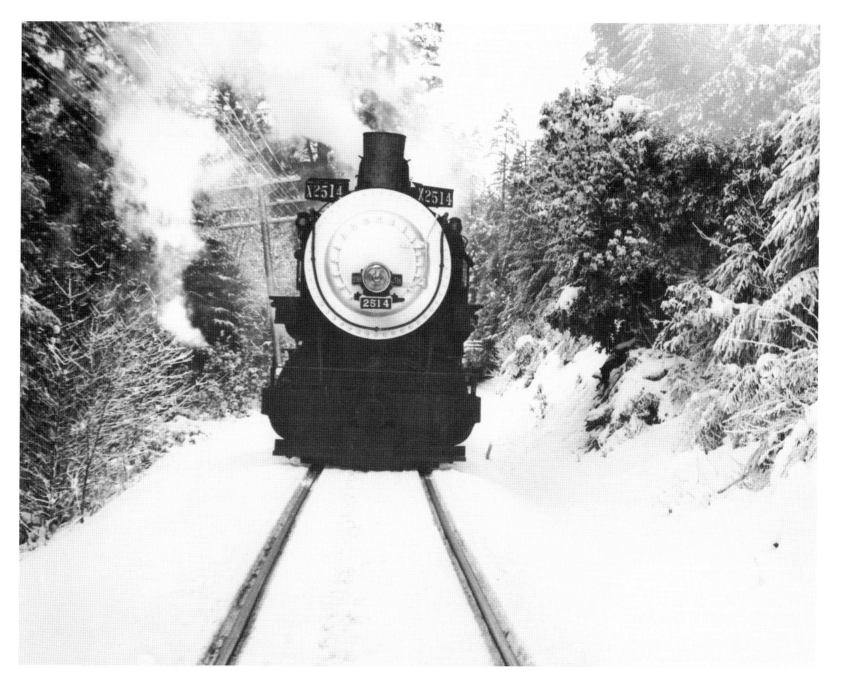

Although Ridge Hill, the highest point on the Northwestern Pacific, is only 1,913 feet above sea level, snow is not unusual. SP 2-8-0 No. 2514 climbs toward the summit amid a world of white. (Courtesy NWPRRHS Archives.)

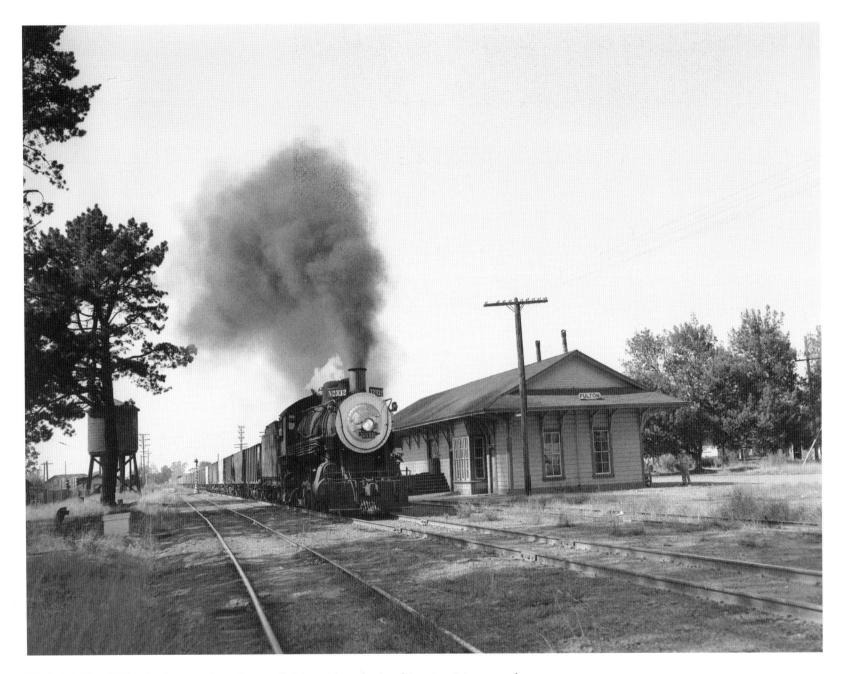

SP 4-6-0 No. 2332 wheels a westbound extra freight with carloads of Russian River gravel through Fulton on August 21, 1950. (Courtesy Alvon J. Thoman.)

At the end of the steam era on the Northwestern Pacific, most of the railroad's locomotives were leased from parent Southern Pacific and were well maintained by the NWP's Tiburon Shops. Following a wreck, SP 4-6-0 No. 2321 is at Cloverdale on September 15, 1951, sparkling in new paint after being rebuilt at Tiburon. (Courtesy Alvon J. Thoman.)

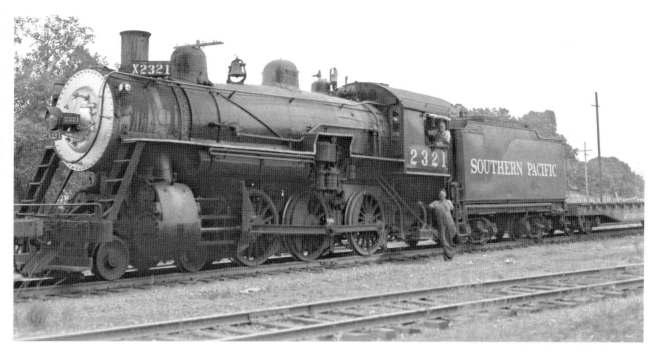

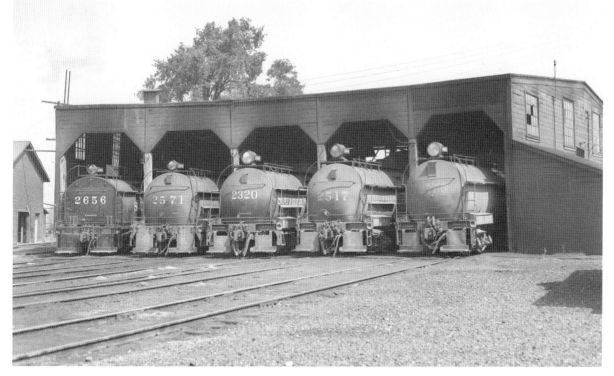

Despite what is often seen in publicity photographs, steam locomotives almost always headed *into* roundhouses so mechanical department crews could work on them. On Sunday, September 16, 1951, five Southern Pacific engines are holed up for a day of rest in the Willits roundhouse. (Courtesy Alvon J. Thoman.)

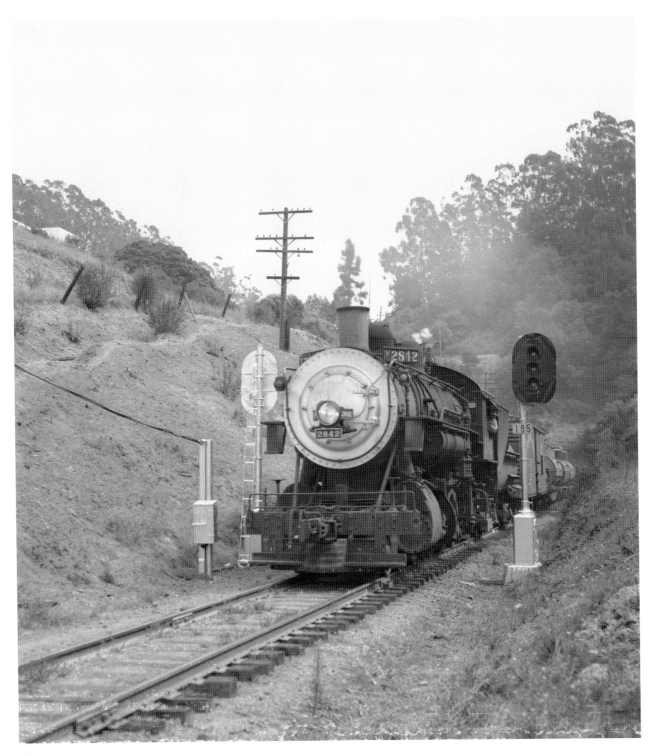

SP 2-8-0 No. 2842 blasts out of tunnel No. 4 and approaches Cerro with a mixed freight on September 15, 1951. (Courtesy Alvon J. Thoman.)

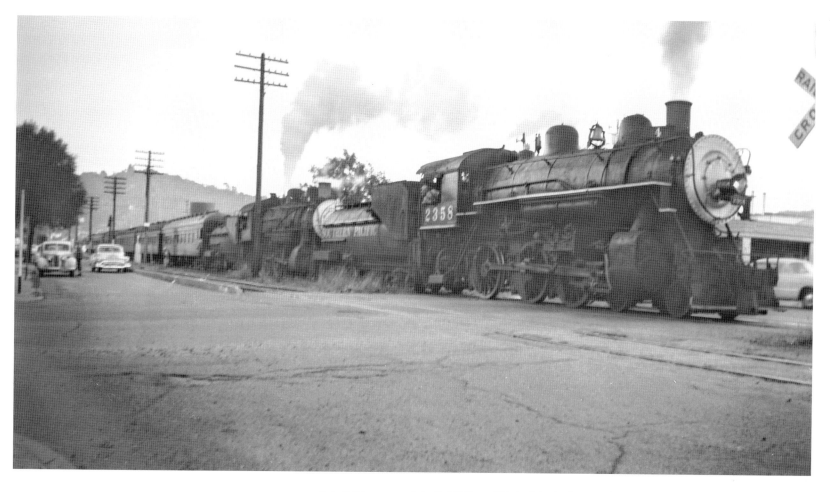

It is 8:30 p.m. on July 3, 1952, and Train No. 4, the Eureka Express, is about to leave San Rafael with a heavy consist. Helper 4-6-0 SP 2358 is coupled to road engine sister SP 2345. The helper will cut off at Cerro, just north of San Rafael's tunnel No. 4. (Courtesy Codoni collection.)

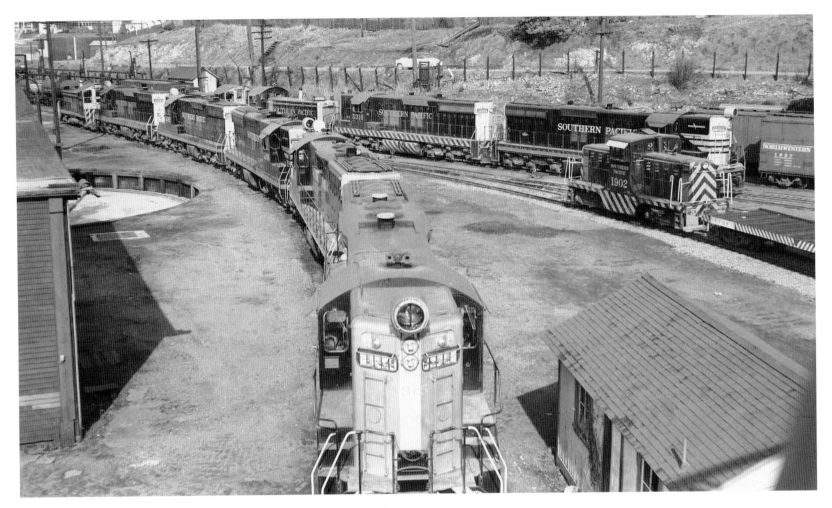

In November 1954, the Tiburon yard is filled with idle diesel locomotives, the result of a Northwestern Pacific engineers' strike. (Courtesy Codoni collection.)

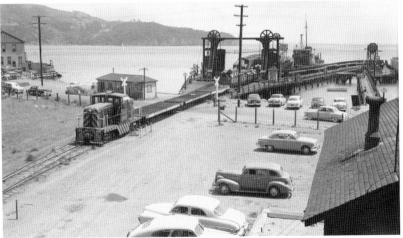

Northwestern Pacific interchanged freight cars with the Atchison, Topeka & Santa Fe Railway at Tiburon by car barge. On July 19, 1953, Switcher No. 1902 shoves cars onto the barge. The three flatcars between the locomotive and other railcars are "reachers," used to prevent the weight of the engine from causing either damage to the apron or the barge to tip into the water. (Courtesy Codoni collection.)

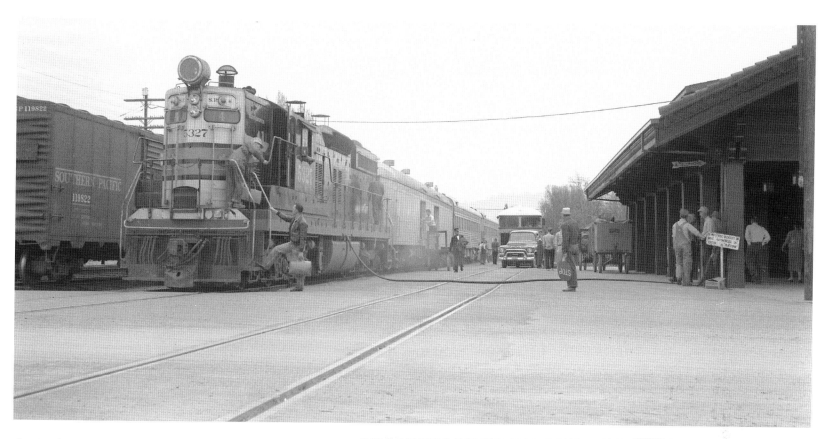

On April 19, 1958, No. 4 has arrived at Willits. The Northern Division crew is climbing aboard SP 5327, while mechanical department employees add fuel to the locomotive. A California Western railcar is behind the pickup truck at right center. (Courtesy David Codoni.)

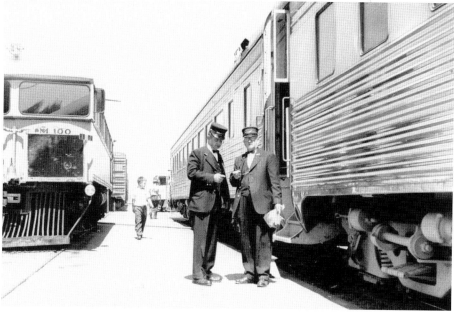

The conductor and brakeman compare watches as Train No. 3, *The Redwood*, prepares to leave Willits for San Rafael. (Courtesy Jim Lekas.)

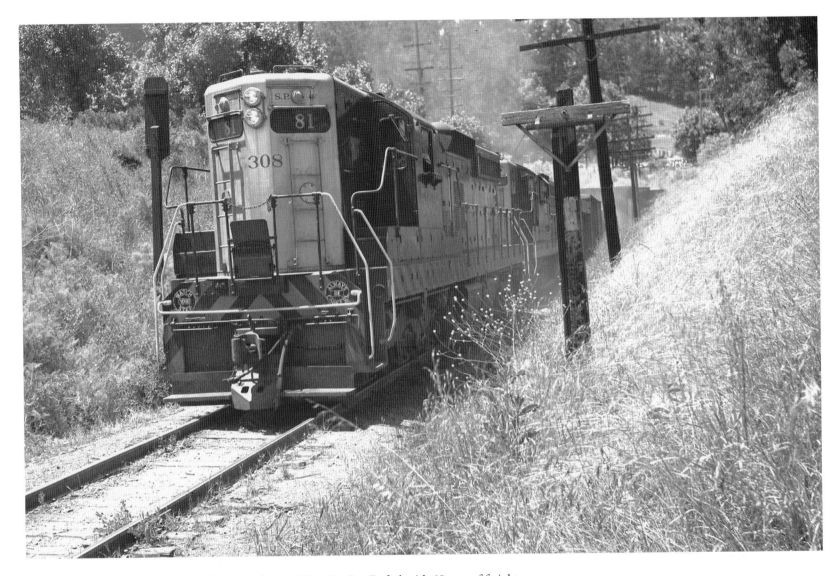

Train No. 81, led by SP No. 5308, blasts out of tunnel No. 4 in San Rafael with 60 cars of freight destined for that city and the Santa Fe interchange at Tiburon. The date is May 27, 1953, and diesel locomotives are handling most of NWP's freight service. (Courtesy Codoni collection.)

OPPOSITE: Engine No. 182 was part of the last job order for new NWP steam locomotives. Nos. 182–184, from Baldwin, joined the roster in 1922. No. 182 would eventually become the last steamer on the NWP, after heading several railfan excursions. This photograph was made at South Fork. (Photograph by W. A. Silverthorn; courtesy NWPRRHS Archives.)

THE NORTH END

As finally constituted, the Northwestern Pacific Railroad was basically three railroads: narrow gauge from Sausalito to Duncan Mills, standard gauge from Willits south to Sausalito (including the electrics), and standard gauge between Willits and Eureka.

The NWP's North End began as a series of short lines that were built primarily to exploit the abundant redwood forests of that region, with an assurance that a railroad could make money moving cargoes of forest products. In 1903, the Atchison, Topeka & Santa Fe Railway created the San Francisco & Northwestern Railway to buy and run these short lines as one. Soon it became a railroad from Eureka south to Shively, with the intent to go all the way to the San Francisco Bay. The Southern Pacific, not to be outdone, extended its rails north from Willits to the Eel River, intending to go to Eureka.

By 1906, the SP and the Santa Fe realized that only one railroad could make money in that region, not two. This led to the 1907 merger, with a total of 42 railroad and franchise antecedents forming the NWP, owned jointly until the Santa Fe sold its half interest to the SP in 1929.

Unfortunately the North End was not photographed as much as the South End, probably because there were fewer northern railfans willing and financially able to record images of the road.

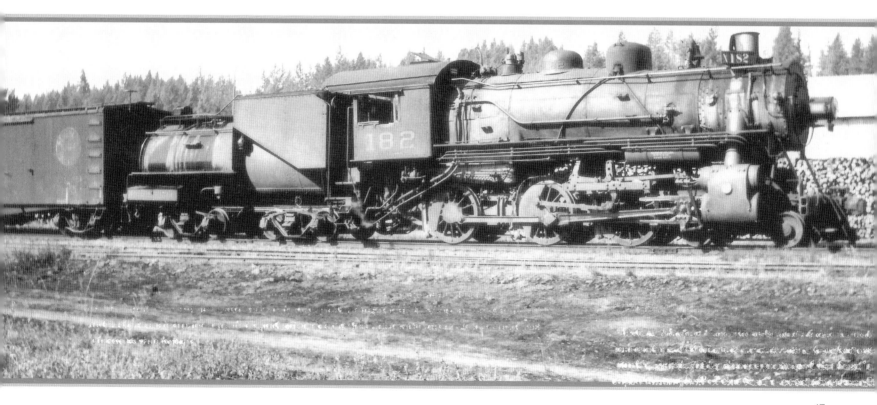

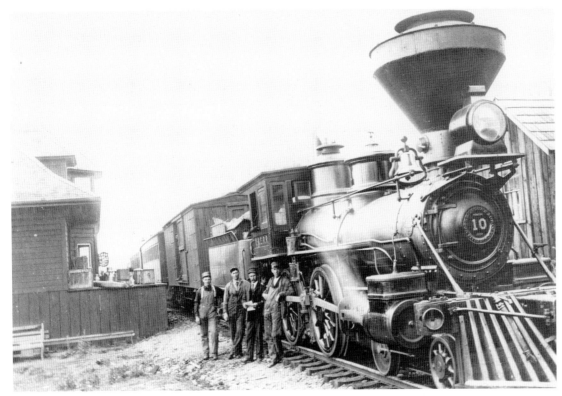

This crew poses proudly with Oregon & Eureka 4-4-0 No. 10 at Luffenholtz. Built by Cooke in 1886, she served on the railroad's line between Samoa and Trinidad and was sold to the Rogue River Valley Railroad in 1905, becoming their No. 3. (Courtesy Codoni collection.)

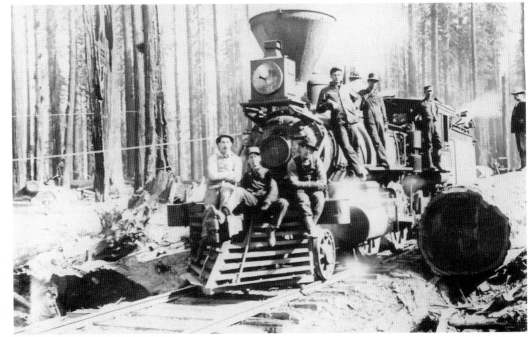

Eel River & Eureka 5 Spot poses in the woods. How many of the men in the photograph are railroaders is unknown. The ER&E was taken over by the San Francisco & Northwestern Railway, formed in May 1903 by the Santa Fe, which wanted to build south from Eureka to the San Francisco Bay area. (Courtesy NWPRRHS Archives.)

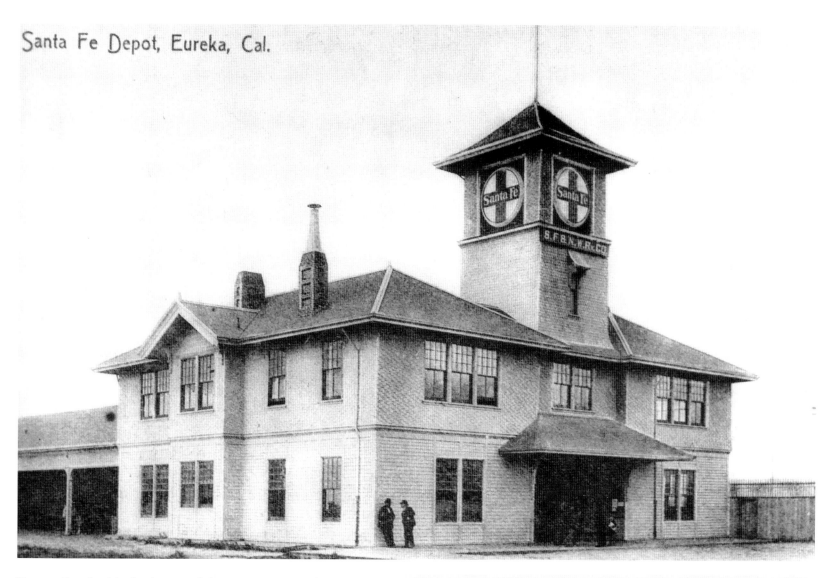

Santa Fe Depot, Eureka, Cal.

For a railroad with the legacy of desert operation such as the Atchison, Topeka & Santa Fe, the depot at Eureka was seemingly out of place. The AT&SF planned to bring its rails south to compete with Southern Pacific, but both deemed the competition too costly. They merged their lines to form the NWP instead. (Courtesy NWPRRHS Archives.)

After the 1907 merger formed the NWP, the Santa Fe herald at Eureka yielded to that of the Northwestern Pacific, which was adopted in early 1910. Ten-wheeler No. 142 was one of the last new locomotives owned by the NWP, purchased in 1922. (Photograph by Wilbur C. Whittaker; NWPRRHS Archives.)

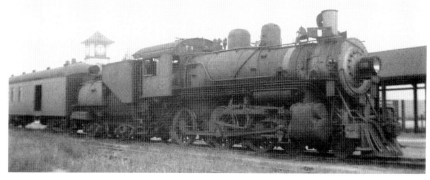

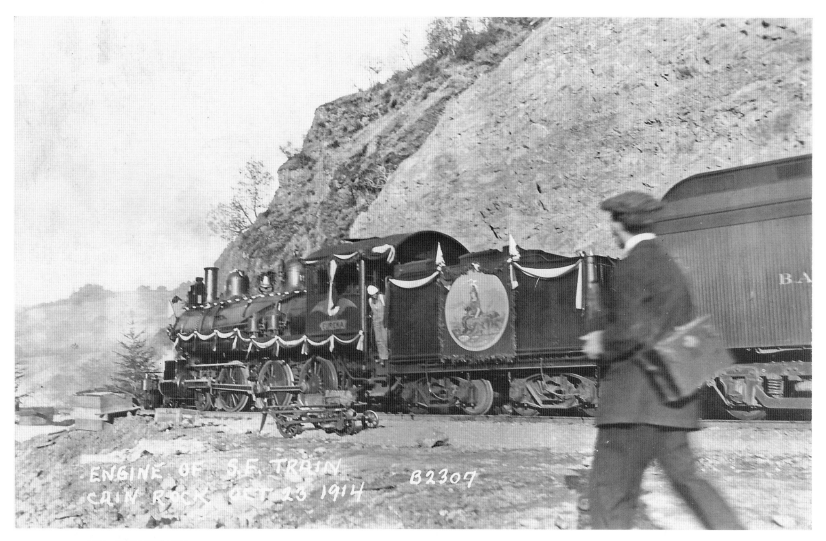

ENGINE OF S.F. TRAIN
CAIN ROCK OCT 23 1914 B2307

On October 23, 1914, Locomotive No. 114 was well dressed for the occasion of driving the Gold Spike at Cain Rock, completing the gap between the North End and the South End of the Northwestern Pacific Railroad. (Courtesy NWPRRHS Archives.)

In later years, the NWP depot at Eureka lost its distinctive tower, but the rest of the exterior seemed little changed—except for the vintage of the cars parked around it. (Courtesy NWPRRHS Archives.)

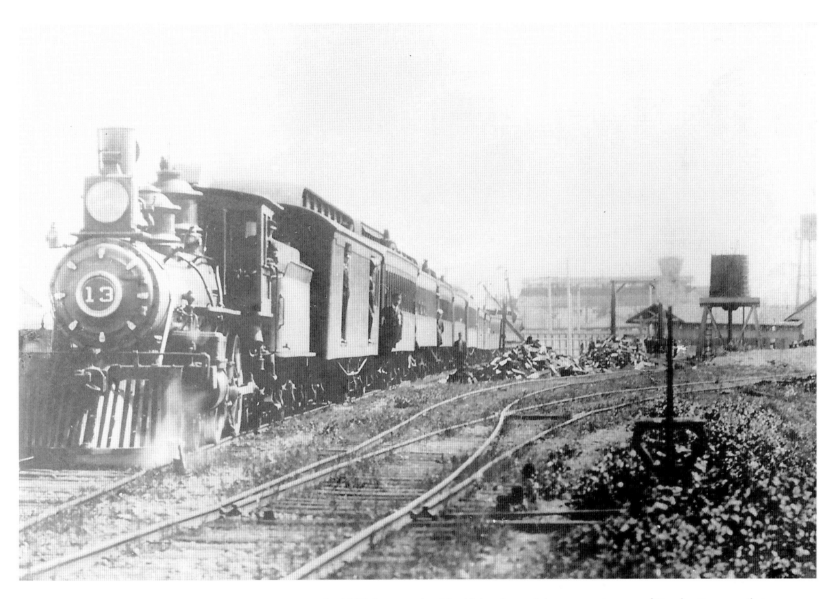

In 1907, Locomotive No. 13 heads an eight-car consist out of Eureka. It seems that everyone wants to get into the picture. (Courtesy NWPRRHS Archives.)

Heading north for Eureka, Locomotive No. 180, on the point of Train No. 4, takes a break. There are still 13.1 miles to go before the run is finished. (Photograph by Fred A. Stindt; courtesy NWPRRHS Archives.)

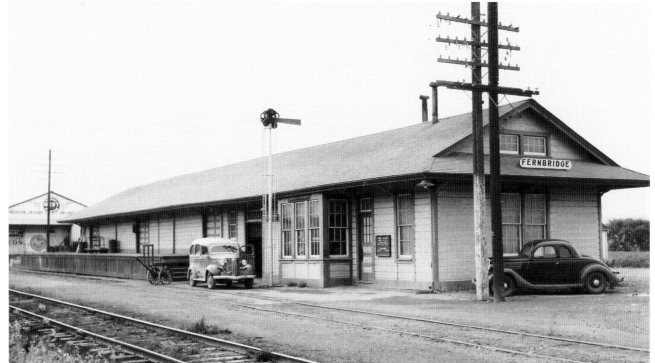

This was the Northwestern Pacific station at Fernbridge, complete with a train board next to the door at the right, a working semaphore signal, handcarts for mail and express packages, telephone poles, and railheads well polished from use. (Courtesy NWPRRHS Archives.)

The fireman on 10-wheeler No. 136 checks the rear of Train No. Extra 136, working at Fernbridge during the 1930s. Locomotive Nos. 136–141 were Alco products, outshopped for the NWP in 1914. (Courtesy NWPRRHS Archives.)

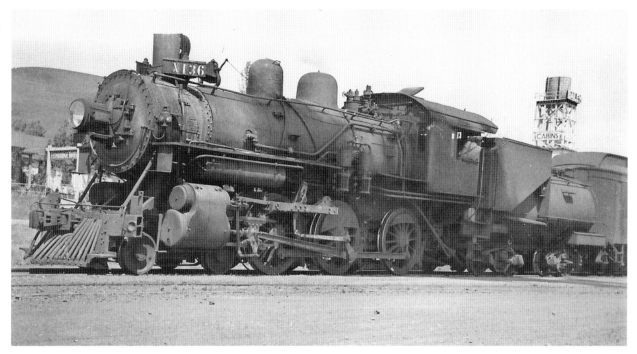

Engine No. 15 is pulling what is probably a work train north of Scotia around 1908. The town of Scotia derived its name from the many lumbermen from Nova Scotia, Canada, who settled there. (Courtesy NWPRRHS Archives.)

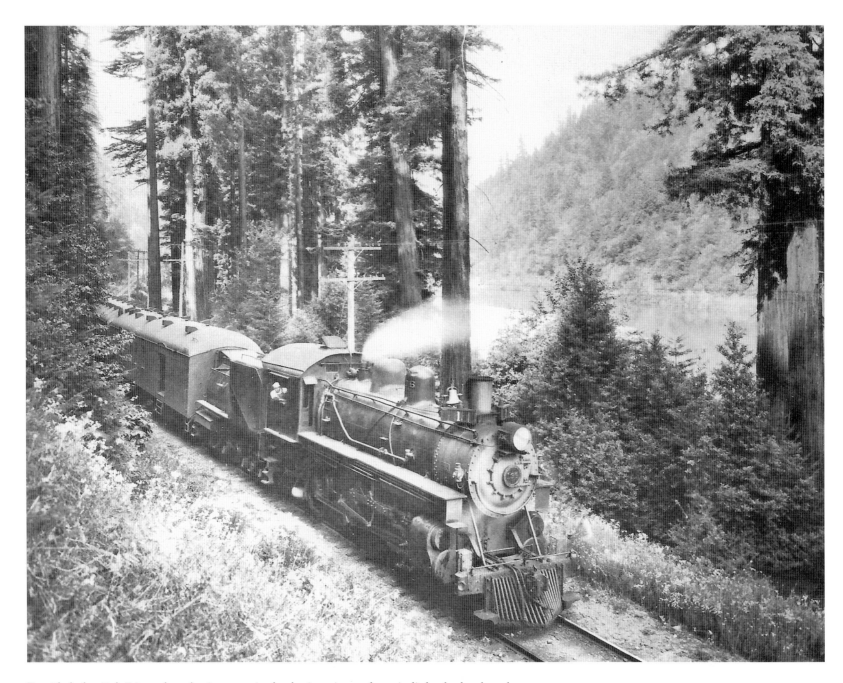

Provided the Eel River doesn't rise over its banks in winter, there is little doubt that the Northwestern Pacific runs along some of the most spectacular scenery in the country. However, geologically, California is new, as evidenced by the changes in landscape when a major earthquake hits or when excessive rainfall comes too quickly for existing natural runoff systems. (Courtesy NWPRRHS Archives.)

Scotia Bluffs, creeping down to the edge of the Eel River, offer splendid scenery while at the same time putting the railroad in danger from mudslides when extraordinary rainfalls hit the Northern California coast. The engine is ex-ER&E No. 3, later NWP No. 151. (Courtesy NWPRRHS Archives.)

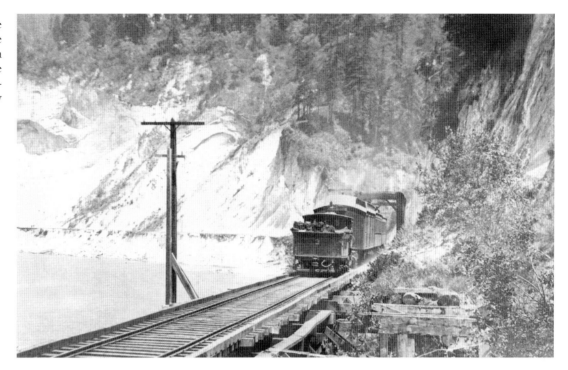

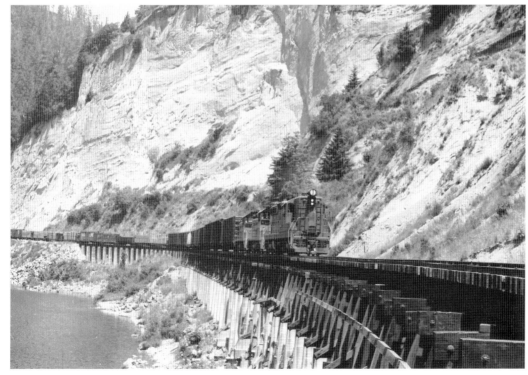

Diesel-electric locomotives altered many of the ways the railroad was run but didn't alter the scenery at Scotia Bluffs. The NWP remained an effective feeder for the Southern Pacific, but both roads found it to be increasingly difficult to compete with big rig trucks. (Courtesy NWPRRHS Archives.)

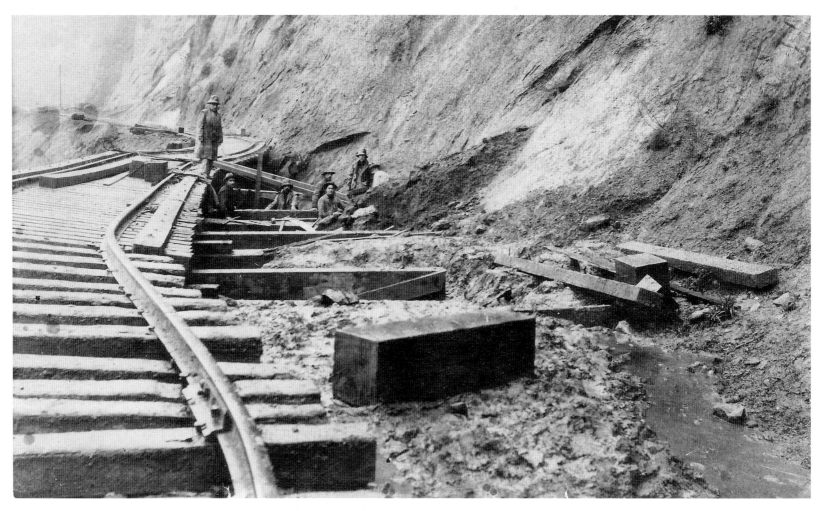

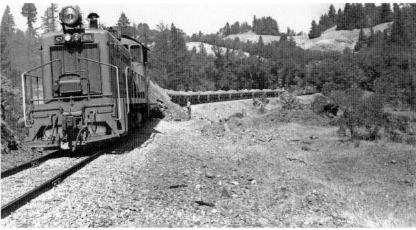

These mudslides and the resultant damage to the NWP at Scotia Bluffs in 1912—two years before the main line was completed—were but a portent of things to come. Even today, the Eel River remains the railroad's worst enemy, along with publicly funded highways. (Courtesy NWPRRHS Archives.)

Southern Pacific diesel No. 4624 heads a train that is dumping riprap along the Eel River Canyon, part of an ongoing battle the railroad faces against the forces of nature. (Courtesy NWPRRHS Archives.)

Despite winter damage, the rains provide the water so necessary for the second and third growths of forests, meaning employment at this Scotia sawmill, photographed in 1959. Forest products traffic at this time still figured heavily in the ledgers of the NWP and SP. (Courtesy NWPRRHS Archives.)

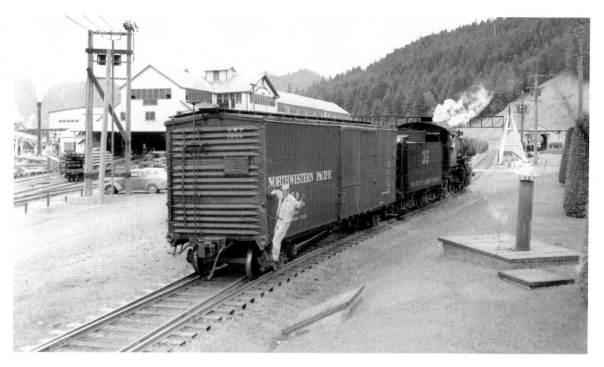

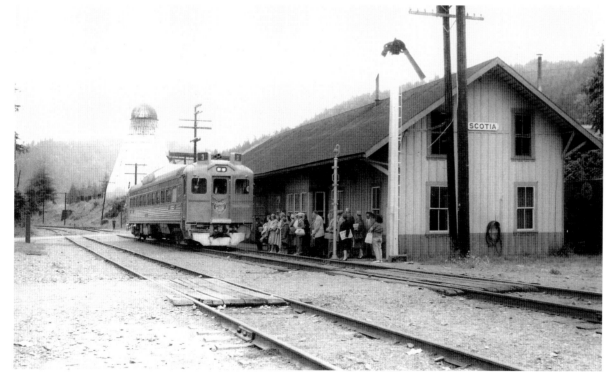

In the latter days of NWP passenger service, the NWP's Budd RDC stops in Scotia. There were enough passengers for the regulators to mandate retention of the thrice-weekly train on the Redwood, but hardly enough to make the train a profitable proposition. (Courtesy NWPRRHS Archives.)

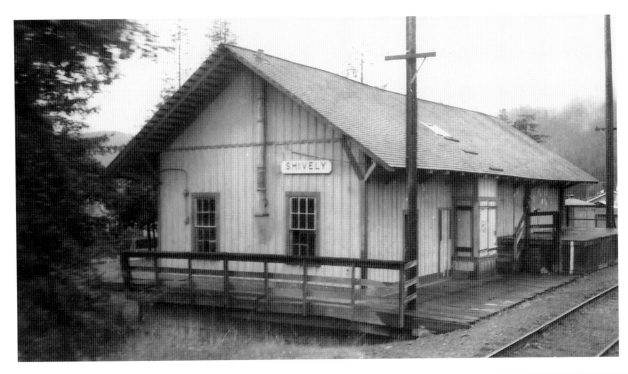

Where Shively didn't rhyme with lively! Shively, 49 miles south of Eureka, once boasted a station agent to handle all the calls for moving logs and finished lumber from local mills. Here the photograph shows a lonely, boarded-up freight shed. (Courtesy NWPRRHS Archives.)

The older station at South Fork was destroyed by fire and replaced with this new structure, which was hard hit by a 1964 December flood and sent floating down the Eel River. South Fork's next station was a brace of boxcars. The station has since been abandoned. (Courtesy NWPRRHS Archives.)

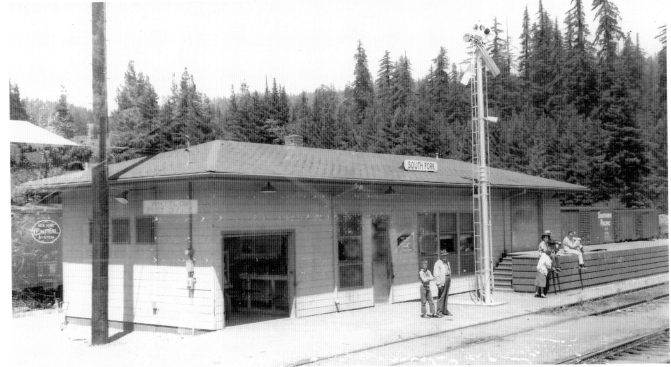

Between 1907 and 1910, this three-car passenger consist stopped at McCann, Milepost 232.2, east of San Francisco's Ferry Building. In NWP terminology, going away from San Francisco is railroad east and the opposite is railroad west, regardless of what the compass reads. (Courtesy NWPRRHS Archives.)

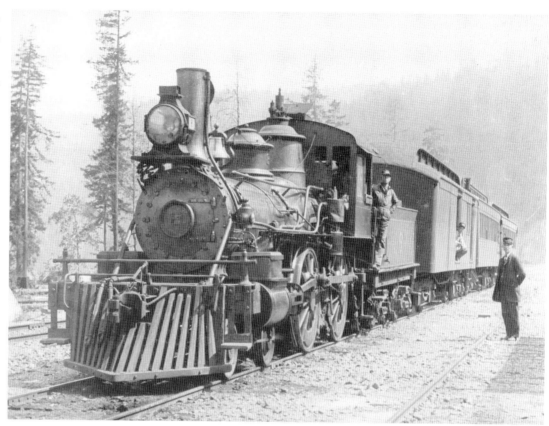

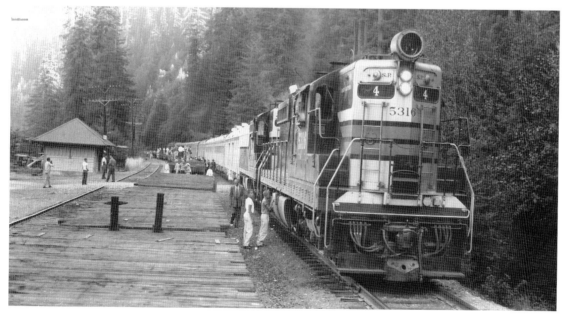

Train No. 4, *The Redwood*, stops at McCann for five minutes on its trip to Eureka from San Rafael. The train ran only three days a week, but to view the world-famous California redwoods from the windows of streamlined coaches was worth the price of the ticket. The nine-car consist and the people climbing on the flatcars indicate that this was a railfan excursion as well as the regularly scheduled train. (Courtesy NWPRRHS Archives.)

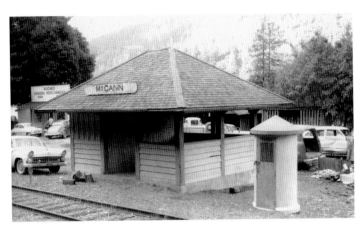

The NWP station at McCann, elevation 185 feet, was little more than a rain shelter for waiting passengers. The small structure at the right of the building was a telephone booth for NWP train crews, quite convenient before the days of cell phones and computers. (Courtesy NWPRRHS Archives.)

The lettering on this postcard reads, "Bird's Eye View/Ft. Seward, Cal." Despite the fact that it must have been a low-flying bird, it is a good view of the NWP main line, a turntable, and one of the many spur tracks into Northern California's forests. (Courtesy Trimble collection.)

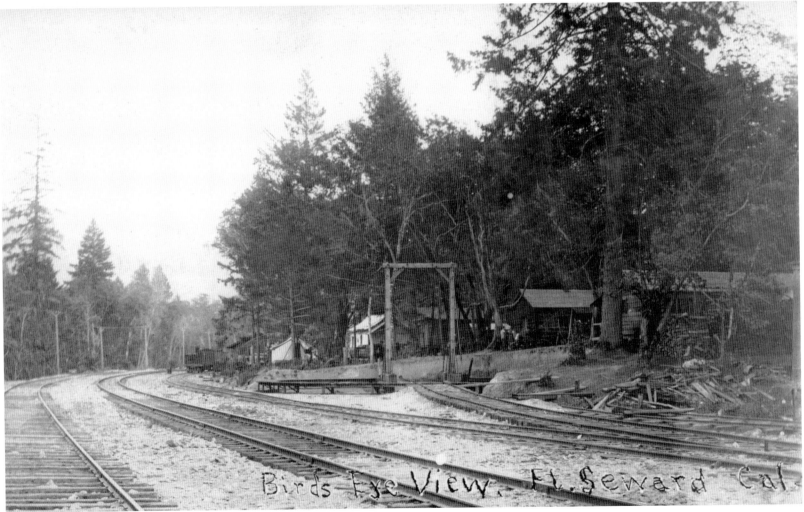

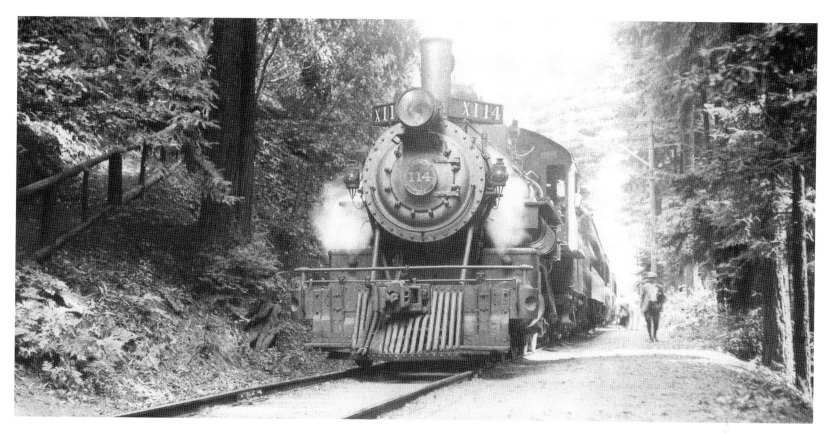

In 1934, A. H. Parsons photographed the beauty of the Northwestern Pacific main line at Eel Rock, complete with an extra passenger train and 10-wheeler No. 114 on the drawbar. California's redwood stands have thrilled hikers and railroad passengers for generations. (Photograph by A. H. Parsons; courtesy NWPRRHS Archives.)

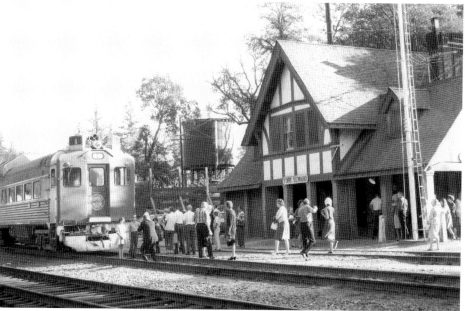

With its semi–Tudor style, the NWP station at Fort Seward was one of the more attractive stations on the North End. The water tank at the center became redundant with the passing of the steam locomotive, yet another reason for conversion to diesel-electric. (Courtesy NWPRRHS Archives.)

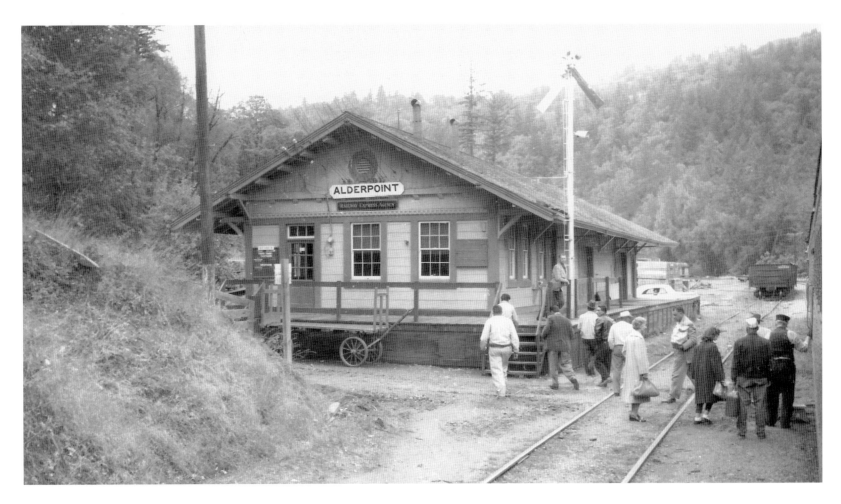

South of Fort Seward was Alderpoint Station, photographed by the late Fred A. Stindt on September 19, 1959. The NWP passenger trains were still running, albeit by order of the California Public Utilities Commission and to the annoyance of the railroad's management. (Photograph by Fred A. Stindt; courtesy NWPRRHS Archives.)

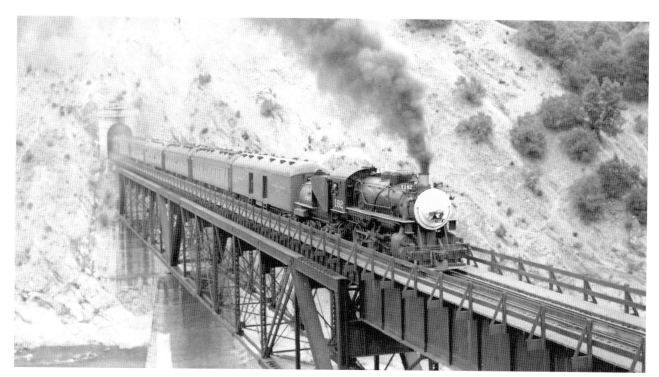

Whatever the motive power on the head end, a train going railroad west out of Island Mountain tunnel onto the trestle, a combination truss and girder, is an ideal subject for any rail photographer. (Both photographs courtesy NWPRRHS Archives.)

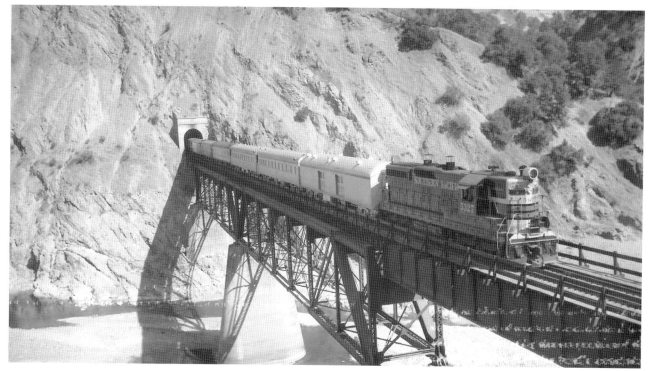

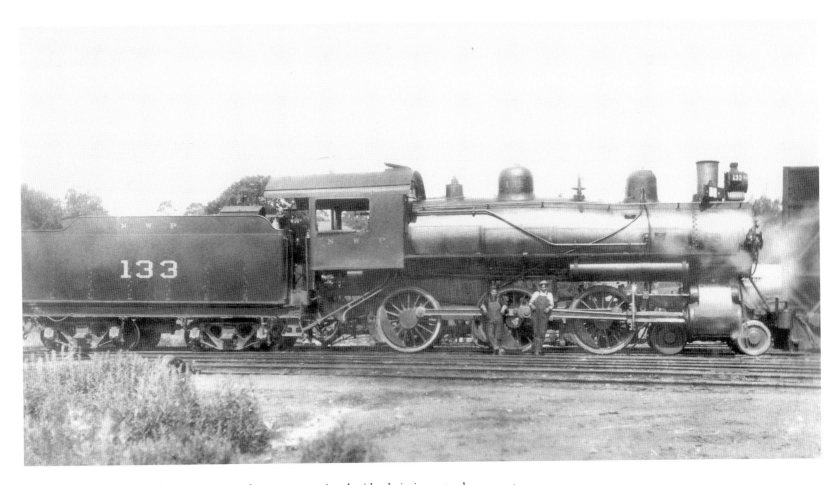

The scene is Willits in 1911, at a time when crews posing beside their iron steeds was not considered loafing. That was also an age when engineers and firemen were regularly assigned to one engine, and the men and "their" locomotives became very close. (Photograph by W. A. Silverthorn; courtesy NWPRRHS Archives.)

OPPOSITE: In 1935, regular passenger service on the Sonoma Valley Branch ended. In June 1940, a special excursion train headed by NWP 10-wheeler No. 112 paused at Boyes Springs. Train No. 112 is the last remaining locomotive from the NWP's extensive roster. She now resides at the California State Railroad Museum in Sacramento. (Courtesy NWPRRHS Archives.)

THE BRANCH LINES

The NWP had several branch lines: the Guerneville (Russian River), Sonoma Valley, Sherwood, San Quentin, Albion, and Carlotta.

The Guerneville Branch was popular with vacationers, who flocked to the Russian River towns it served. It left the main line at Fulton and meandered along the river to dozens of summer resorts. Originally built to tap the timber in western Sonoma County, it became mostly a passenger route when the forests were logged out. The last train ran in 1935.

The Sonoma Valley Branch left the main line at Ignacio, went to the Valley of the Moon via Sonoma, and ended at Glen Ellen. Vacationers, weekenders, and day-trippers rode the trains to historic Sonoma and the spas at places like Boyes Hot Springs and Fetters Springs. Passenger service on the branch ended in 1935, and freight service north of Sonoma was discontinued the same year.

The line between Willits and Sherwood was part of the original main line, but was relegated to branch-line status when the NWP was completed through to Eureka in 1914. Trackage was cut back twice in 1930, and the last 14.5 miles between Willits and Williams were torn up in 1933.

The San Quentin Branch was the first railroad in Marin, a standard-gauge line built in 1870 from San Rafael's B Street to a ferry connection at Point San Quentin. It was abandoned in pieces, the last part being torn up in 1946.

The Albion Branch never connected to the NWP. It ran from the mill at Albion into the woods, ending about 25 miles southeast in Christine. The NWP took it over in 1907, and soon NWP surveyed routes between Christine and the NWP main line. The cost of constructing the connection was excessive, and it was never built. The branch was abandoned in 1930.

The Carlotta Branch extended five miles from Alton to Carlotta. At Carlotta, the rails connected with the Pacific Lumber Company's private railroad up Yager Creek into the woods. Pacific Lumber's logging railroad is long gone, but the rails are still in place on the branch.

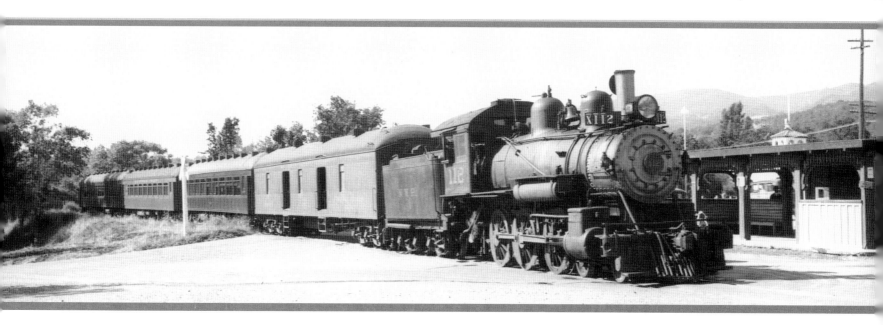

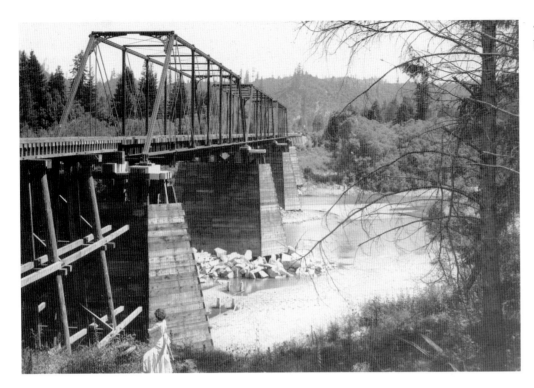

The SF&NP crossed the Russian River on this spindly bridge near Rio Campo. (Courtesy Codoni collection.)

This outlandish looking 0-4-0 spent her career hauling logs and local passengers on the Guerneville Branch. She was nicknamed Coffee Grinder for the mechanism on front that was used to drag logs. (Courtesy NWPRRHS Archives.)

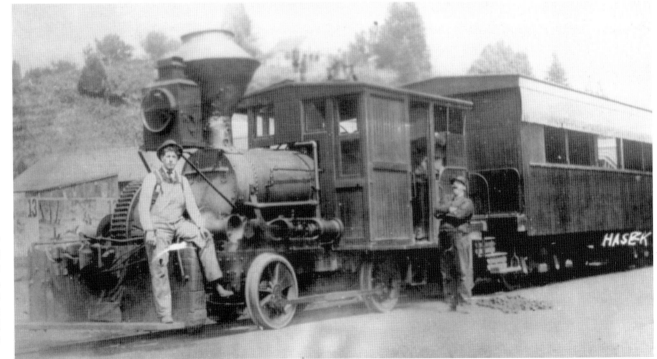

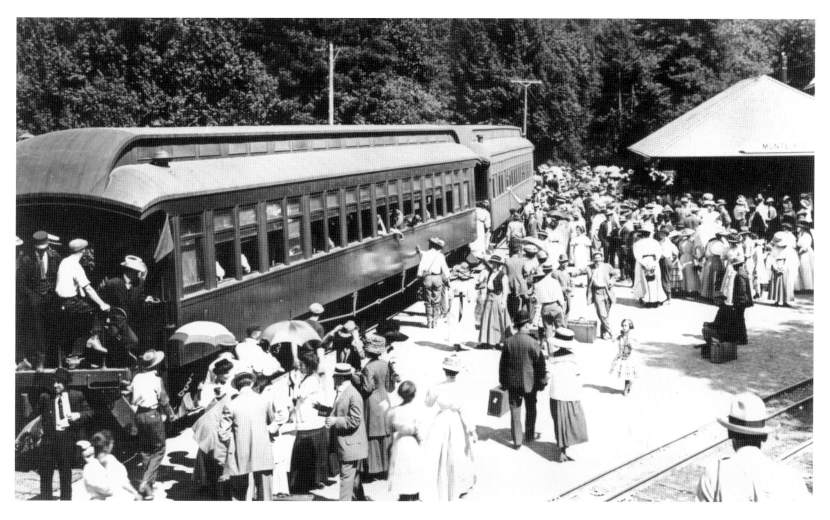

Hundreds of picnickers and vacationers wait to board the standard gauge train at Monte Rio on a busy Sunday afternoon. Monte Rio was the junction between the narrow-gauge route via Tomales and Point Reyes Station to Sausalito and the standard-gauge route via Fulton and Santa Rosa to Sausalito. Note the three-rail track at right to accommodate both standard and narrow-gauge trains. (Courtesy NWPRRHS Archives.)

At the Russian River – Guerneville, Calif.

This postcard view shows the main line of the NWP's Guerneville Branch running down the main street of the town for which it was named. (Courtesy NWPRRHS Archives.)

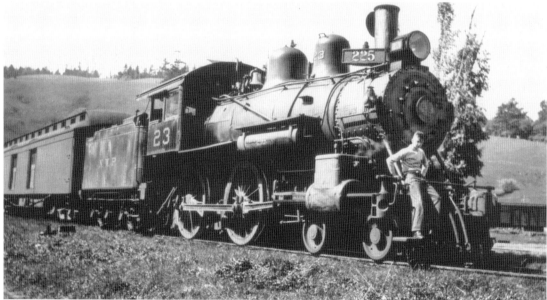

American-type engine No. 23, pictured here as Train No. 225, waits at Duncan Mills for its Sunday-only departure for Sausalito. Sunday passenger traffic was particularly heavy on the Russian River Branch, with thousands seeking a day in the sun on the river. (Courtesy NWPRRHS Archives.)

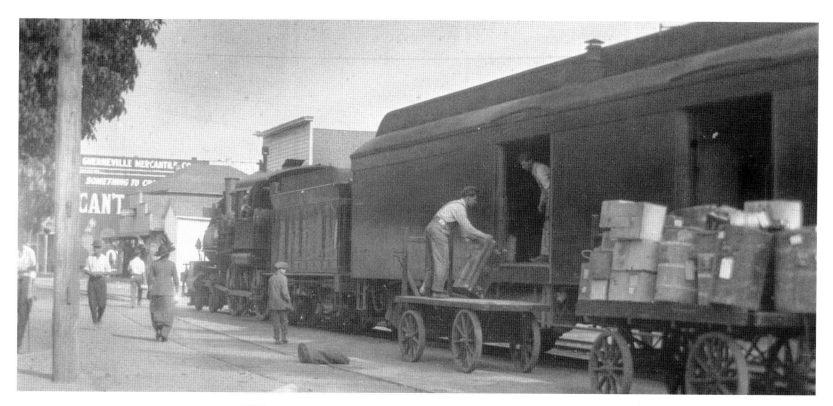

The arrival of each train was a big event in Guerneville, as it was in most small towns throughout the United States. Here the afternoon passenger train has stopped on Guerneville's main street to unload baggage, mail, and express. (Courtesy NWPRRHS Archives.)

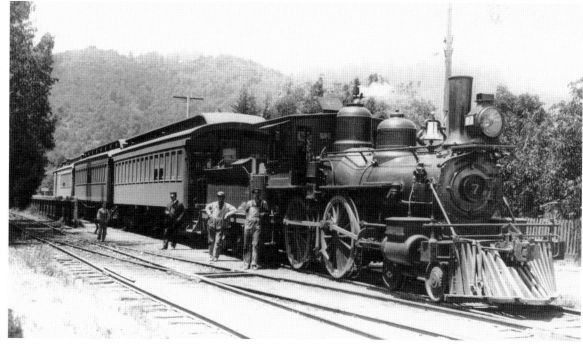

Around 1890, SF&NP No. 7 has two coaches and a combine in tow, as she and her crew pause in Guerneville. (NWPRRHS Archives.)

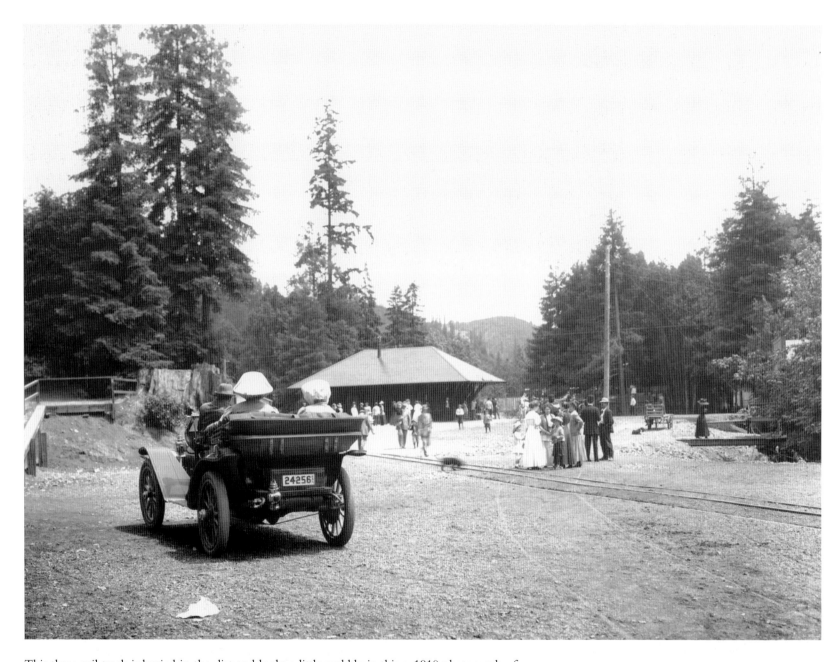

This three-rail track is buried in the dirt and looks a little wobbly in this *c.* 1910 photograph of the Monte Rio depot area. (Courtesy Codoni collection.)

Train No. 223, the afternoon Duncan Mills-Sausalito passenger service train, has a baggage car and three coaches as it pauses in Guerneville. It will take it almost three hours to reach Sausalito and another 32 minutes for its passengers to arrive in San Francisco via ferry. (Courtesy Codoni collection.)

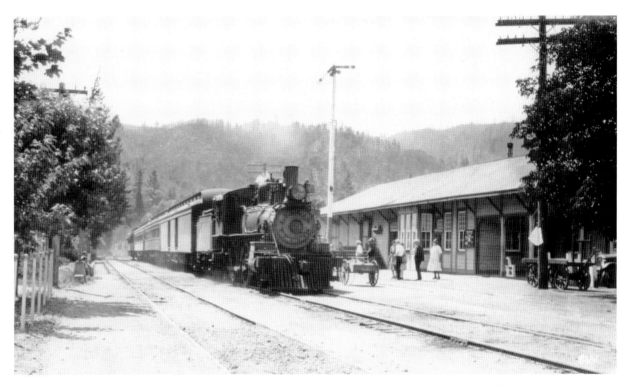

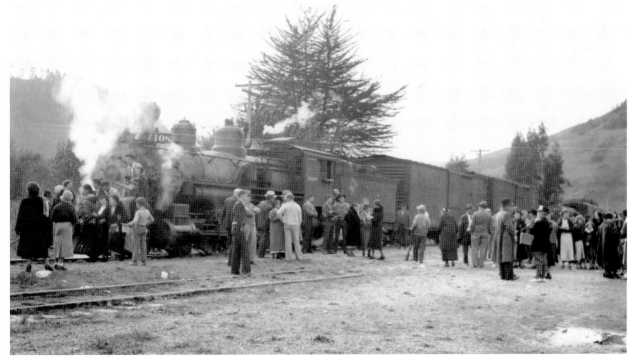

It's a sad ending for the once-busy Russian River Branch as passengers and spectators gather at Duncan Mills for the last run to Fulton. Engineer Billy Burns is at the throttle as 10-wheeler No. 108 prepares to leave this depot for the last time on November 14, 1935. (Courtesy NWPRRHS Archives.)

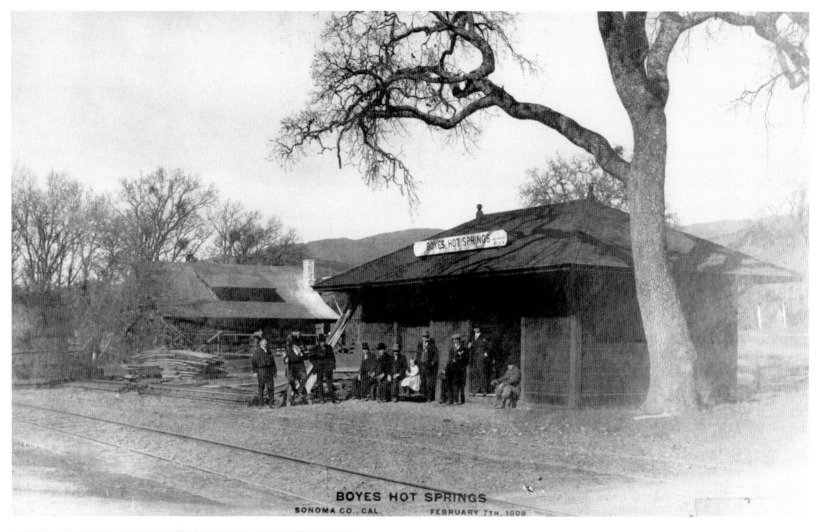

BOYES HOT SPRINGS
SONOMA CO., CAL. FEBRUARY 7TH, 1908

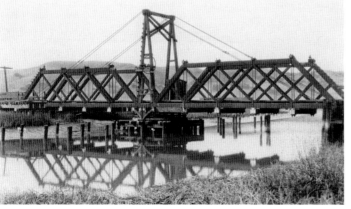

In 1908, passengers wait for the train at the shed depot at Boycs Hot Springs. Boyes Hot Springs, just two miles north of Sonoma, was one of the many resorts in the Valley of the Moon served by Northwestern Pacific's Sonoma Valley Branch. (Courtesy NWPRRHS Archives.)

The swing bridge at Wingo was operated by hand for the occasional boat that desired passage up Sonoma Creek. At one time, Wingo was a connection to the Southern Pacific and one train a day in each direction traveled between Sausalito and Calistoga via NWP to Wingo and SP to Calistoga. In 1921, this bridge was replaced with a steel span. (Courtesy Codoni collection.)

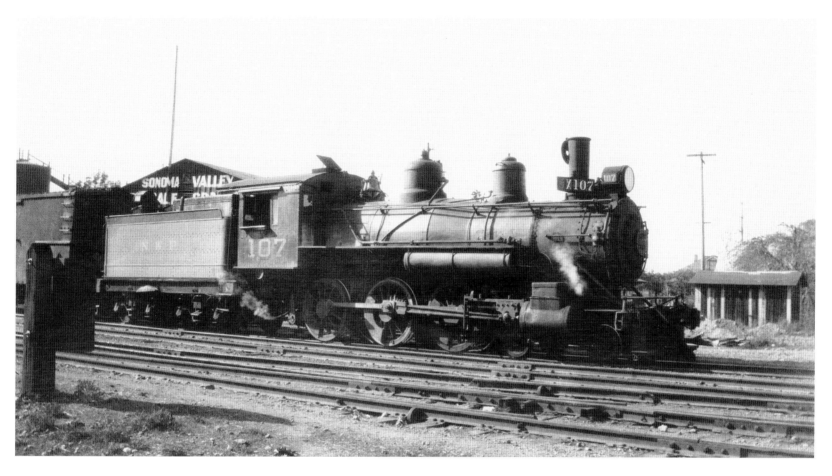

NWP 10-wheeler No. 107, built by Baldwin Locomotive Works in 1904 as San Francisco & North Pacific No. 22, handled many freight assignments, including this one on the Sonoma Valley Branch in Sonoma. By 1937, she was off the NWP's roster, a victim of age and declining business during the Great Depression. (Courtesy NWPRRHS Archives.)

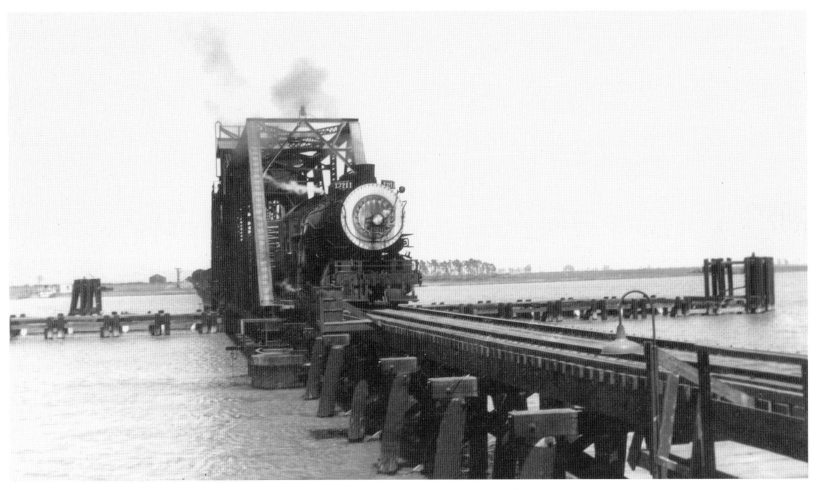

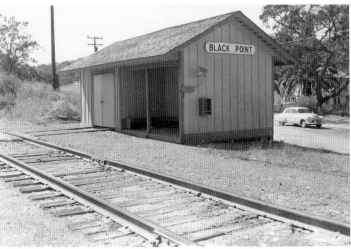

Extra West No. 3211 crosses the Petaluma River on the swing bridge at Black Point with a train of mostly empty cars destined for loading in the Redwood Empire. The bridge was normally set for rail traffic and was opened only when river traffic was passing. Drawbridge tenders were on duty for three shifts every day of the year until rail traffic declined dramatically. Thereafter the bridge was set for water traffic and closed only when infrequent trains needed to cross. (Courtesy Codoni collection.)

Black Point was a flag stop for passenger trains until service on the Sonoma Valley Branch was discontinued in 1935. When this photograph was taken 20 years later, the flag was still attached to the side of the shelter, ready for passengers who will never come again. (Courtesy Codoni collection.)

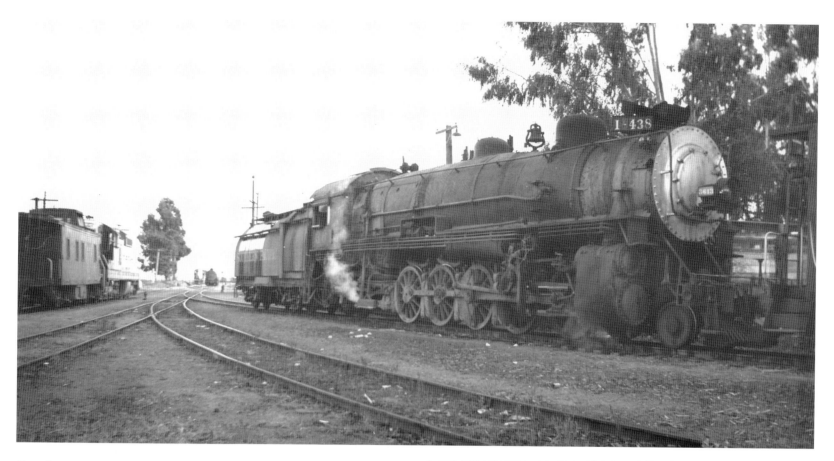

On a late summer afternoon in September 1953, a heavy SP 3600-class locomotive has been uncoupled from the train after delivering freight cars to the NWP interchange at Schellville. There must have been many cars coming to the NWP that day—indicators on the locomotive show it was hauling "First 438," meaning that at least one more section would be arriving. (Courtesy Codoni collection.)

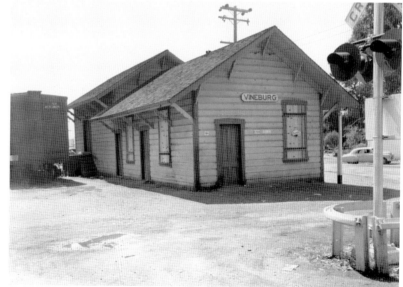

Vineburg, just south of Sonoma, was once a busy station on the NWP's Sonoma Branch, but by the time this picture was taken in the 1950s, it was abandoned and the windows boarded up. (Courtesy Codoni collection.)

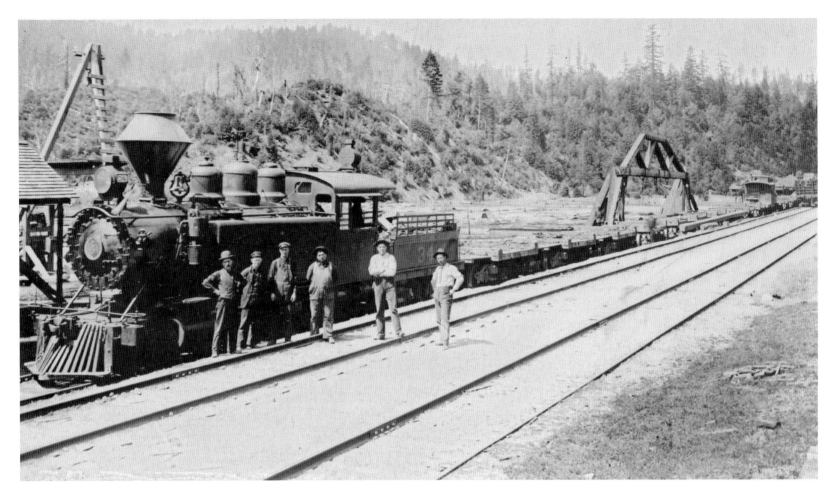

The Sherwood Branch was all about timber. Engine No. 34 and her crew have finished dumping logs into the Sherwood millpond and are posing for the camera before their next run into the woods. (Courtesy NWPRRHS Archives.)

NWP's Sherwood Branch, extending northwest from Willits, was part of the original main line from Tiburon and served lumber mills. Lima-built Shay No. 251, pictured here in helper service on the Sherwood Branch about 1925, was the NWP's only Shay-geared locomotive. (Courtesy NWPRRHS Archives.)

There was nothing fancy about the Sherwood Branch. The track was unballasted, and Woodpecker Station was simply an old boxcar. Note that the station is identified by the chalked words "Woodpecker Spur" on the boxcar. (Courtesy NWPRRHS Archives.)

The mill at Albion supplied much of the traffic for the Albion Branch, which ran from the port of Albion on the Pacific Ocean southeasterly to Christine. It had no physical connection with the Northwestern Pacific Railroad but served to haul logs to the mill and lumber to the port for transfer to ships. The branch ceased operations in 1930 and was torn up in 1937. (Courtesy Codoni collection.)

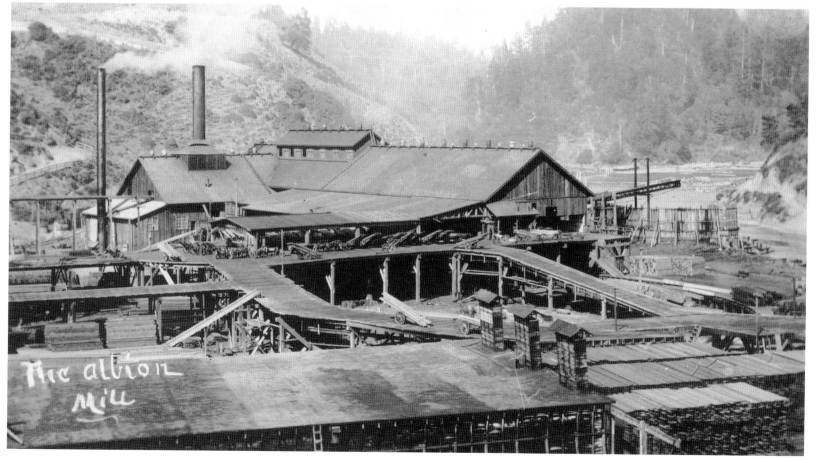

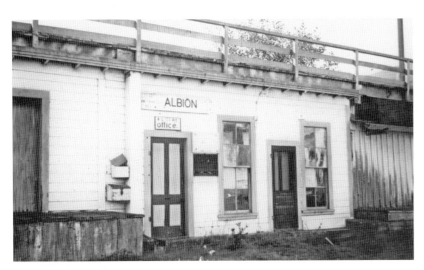

The Albion "depot" was also the office of the Albion Lumber Company. Barely visible on the sign over the door is "San Francisco 153 miles," optimistic reference to the main line connection that was proposed but never built. (Courtesy Codoni collection.)

In 1937, tiny 0-4-0, saddle tank No. 4 was used in tearing up the orphan Albion Branch. NWP engineer Bill Hopper is standing beside the engine. (Courtesy Edward H. Nervo.)

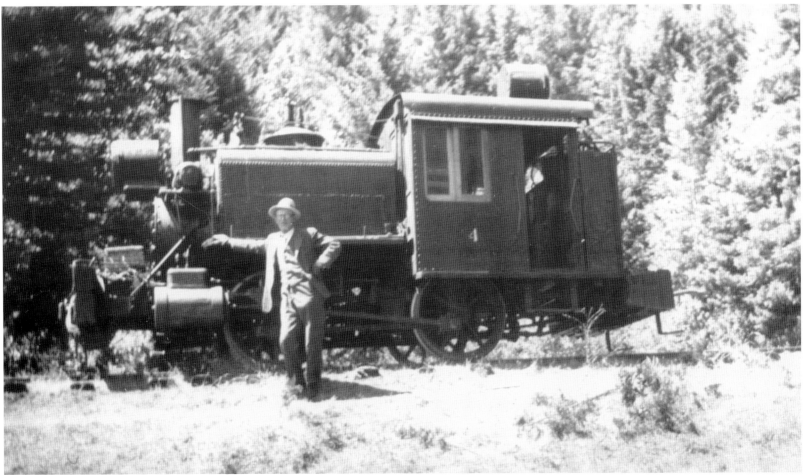

The Carlotta Branch left the main line at Alton, pictured here, diverging to the right of the photograph. Note the stub switch leading to the house track. (Courtesy NWPRRHS Archives.)

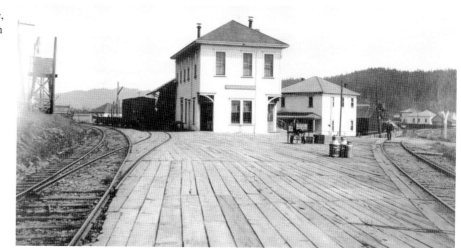

Holmes-Eureka Lumber Company's two-truck Lima Shay No. 2 is waiting at Carlotta in 1938 while logs are being loaded onto its flatcars. (Courtesy Codoni collection.)

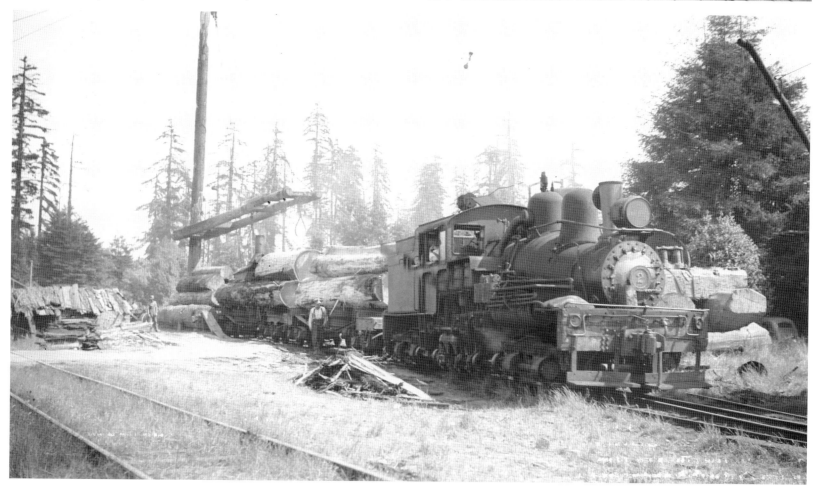

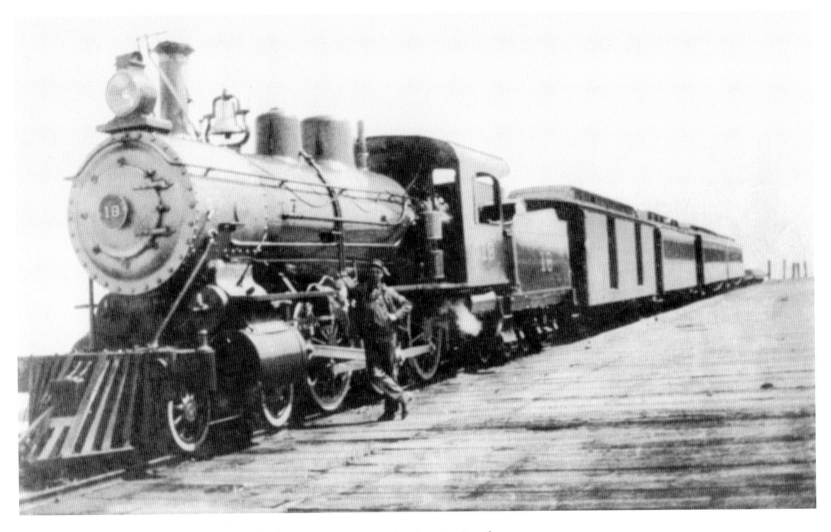

NPC 4-6-0 No. 18 waits at the San Quentin dock for passengers from the San Francisco ferry. (Courtesy NWPRRHS Archives.)

OPPOSITE: NWP remodeled gas-electric No. 900 by squaring off the nose and moving the engineer's compartment to the front. In 1920, NWP 900 was put into service on the Manor-Lagunitas and Manor-Point Reyes trains. At that time, the daily schedule called for two round trips between Manor and Lagunitas and one round trip between Manor and Point Reyes. There was added service on Sundays. With population increasing in the San Geronimo Valley, NWP added more trains until, by 1930, daily service featured five round trips between Manor and Lagunitas and three round trips between Manor and Point Reyes Station. In 1933, all service on the line was discontinued. (Courtesy NWPRRHS Archives.)

INTERURBANS AND DOODLEBUGS

The need for interurbans to haul commuters between Marin County and San Francisco was a major impetus for constructing railroads in Marin, which once boasted first-class suburban service. Its heavyweight railcars ran on well-built, well-maintained track.

In 1902, John Martin and Eugene de Sabla Jr. purchased the narrow-gauge North Pacific Coast, renamed it the North Shore Railroad, and began electrifying its suburban lines. The interurban cars were standard gauge and so a third running rail was laid, making it possible for both narrow- and standard-gauge equipment to use the same track. To power the interurbans, the company laid a fourth rail (referred to as the "third rail") to carry the 600-volt direct current to the cars.

On August 20, 1903, electric service began between Sausalito and Mill Valley. Soon electric trains were running to San Rafael, Fairfax, and Manor. The trains were popular until automobiles and the Depression reduced passenger count. The opening of the Golden Gate Bridge in March 1937 was the death blow. On February 28, 1941, the last electric trains ran.

Self-powered passenger cars, known as doodlebugs, came about as NWP sought ways to revive its passenger business by replacing steam trains and therefore reducing operating costs. In 1930, NWP purchased four diesel-electric railcars and leased nine coaches, using that equipment to replace steam-powered trains on the main line. By that time, the NWP had had nine years of experience with self-powered passenger cars,

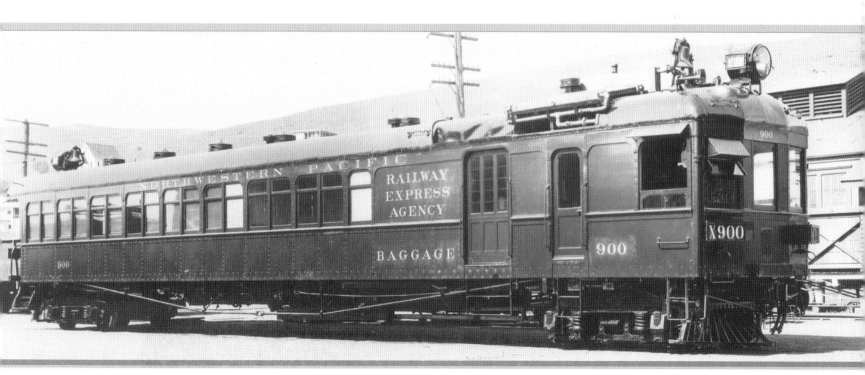

having put gas-electric No. 900 into service in 1921 for the Manor–Lagunitas run. The new motors usually pulled a baggage-mail-express car and two or three coaches.

Two of the cars remained on the Sausalito–Eureka day trains (Nos. 1 and 2) until 1941, when they were replaced by SP gas electrics Nos. 7 and 11. The NWP returned No. 7 and No. 11 to SP in March 1942, shortly before discontinuing the day trains.

On May 25, 1959, the self-propelled passenger car returned to the NWP. SP's Budd-built RDC-1 No. 10 replaced a locomotive-powered train on the triweekly Willits–Eureka run and handled NWP's passenger service until it was discontinued on April 30, 1971.

On August 20, 1903, the North Shore's first electric train leaves the main line at Mill Valley Junction (later Almonte) for the trip to Mill Valley. In the same year, electric trains began running to San Rafael via San Anselmo. (Courtesy Codoni collection.)

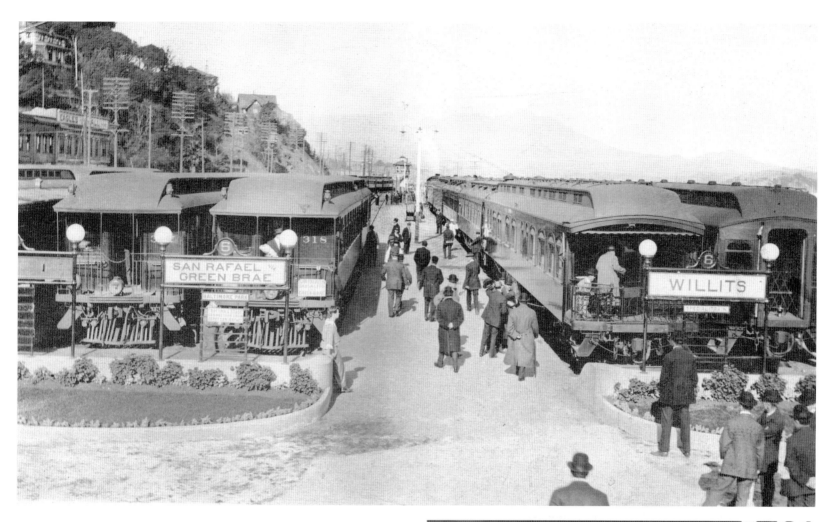

Electric interurban trains arrived and departed at the left side of Sausalito's passenger terminal, while steam trains used the right side. In this 1914 view, trains at right are bound for the October 23 Golden Spike ceremony at Cain Rock, between Willits and Eureka. (Courtesy Codoni collection.)

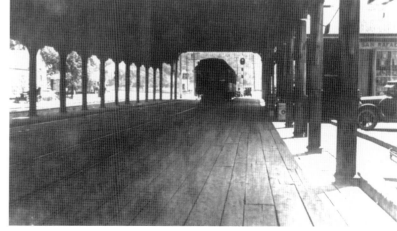

San Rafael's original Union Depot was a dank, gloomy place to board interurban trains. (Courtesy Codoni collection.)

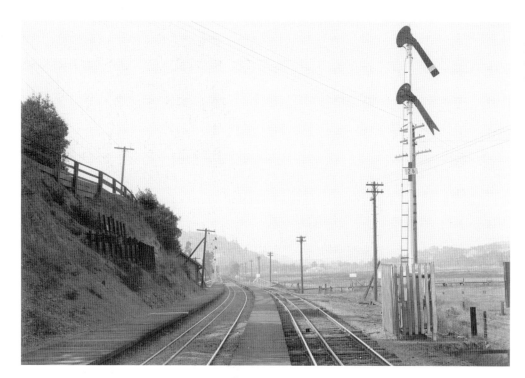

Four-rail track at Escalle, between Larkspur and Kentfield, allowed narrow-gauge trains to run on the same track as the standard-gauge electric interurbans. The double track was protected by block signals. (Courtesy Codoni collection.)

The Mill Valley Branch was single track. For several years after the North Shore interurban line was opened to the town at the foot of Mt. Tamalpais, a third running rail allowed narrow-gauge trains to access the line. The electric third rail was covered at stations but not at other places. Over the years, there were several people injured or killed by making contact with the third rail, but most deaths were of animals. Dogs who mistook the third rail for a fire hydrant or a tree usually were never able to repeat the mistake. Livestock, who wandered onto the track and contacted the third rail, often suffered a similar fate. (Courtesy Codoni collection.)

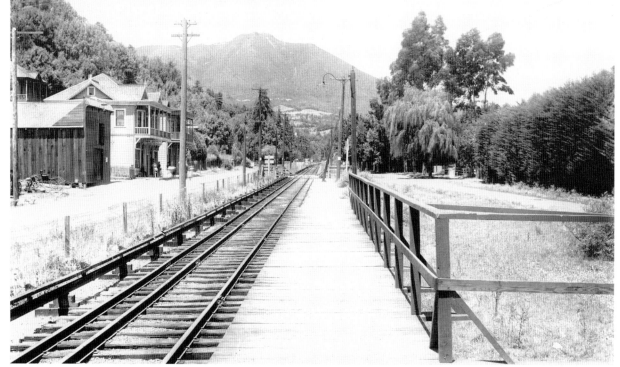

Manor was the westernmost station on the interurban electric line. Passengers for Point Reyes Station and locations in the San Geronimo Valley transferred to steam teams here. (Courtesy NWPRRHS Archives.)

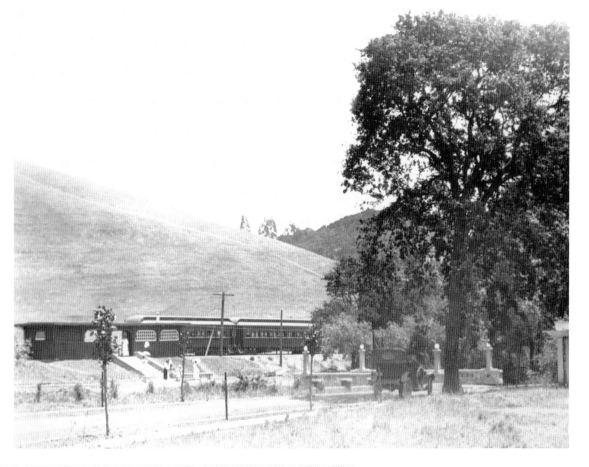

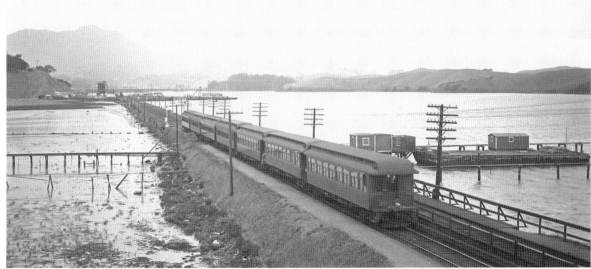

Interurban trains ran along Richardson Bay on landfill. In this photograph, a seven-car, rush-hour train is speeding along the well-maintained right-of-way toward Sausalito and the ferry connection to San Francisco. (Courtesy Codoni collection.)

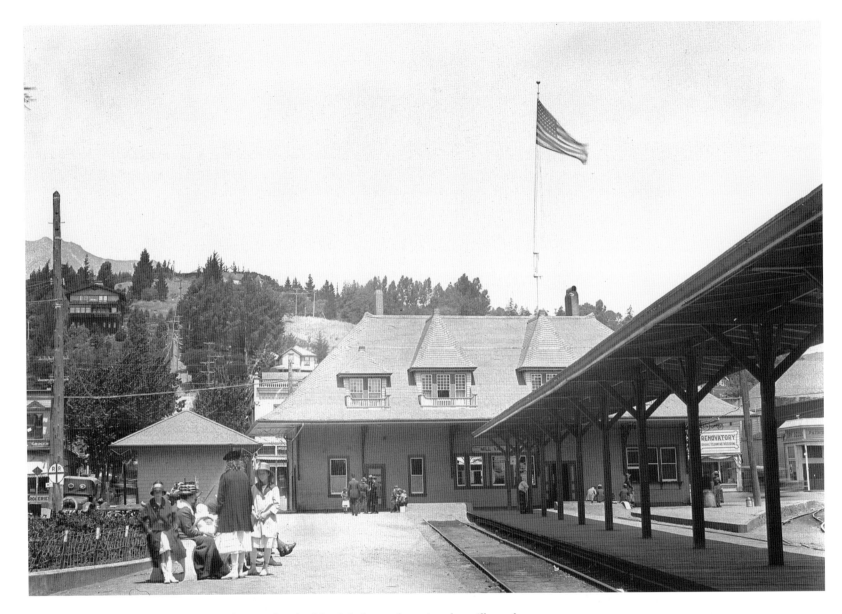

This handsome depot at Mill Valley was later replaced with a Mission–style station that still stands in 2005. Tracks of the Mount Tamalpais & Muir Woods Railway, which climbed eight and a half miles to the top of Mount Tamalpais and had a branch to Muir Woods, are just visible at far right. (Courtesy Codoni collection.)

Tunnel No. 1, between Alto and Chapman, was built for the narrow-gauge North Pacific Coast, but fortunately was constructed to standard-gauge dimensions. This allowed standard-gauge North Shore and NWP electric trains to pass through it without modification. The bore was never double-tracked and movements through it were governed by automatic block signals. (Courtesy NWPRRHS Archives.)

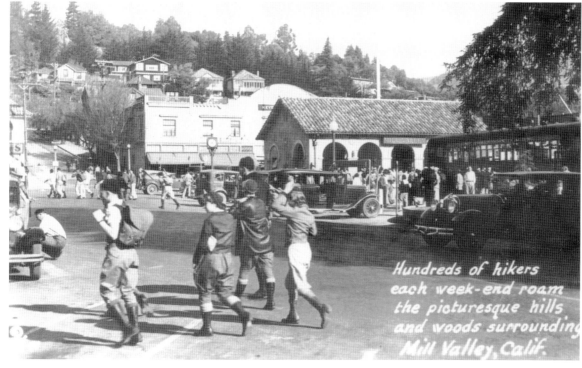

Hundreds of hikers each week-end roam the picturesque hills and woods surrounding Mill Valley, Calif.

Sundays found hikers of both sexes and all ages riding the electric trains to Mill Valley to climb Mount Tamalpais. Savvy travelers rode the Mount Tamalpais & Muir Woods Railway to the summit of the mountain and then hiked down. (Courtesy Codoni collection.)

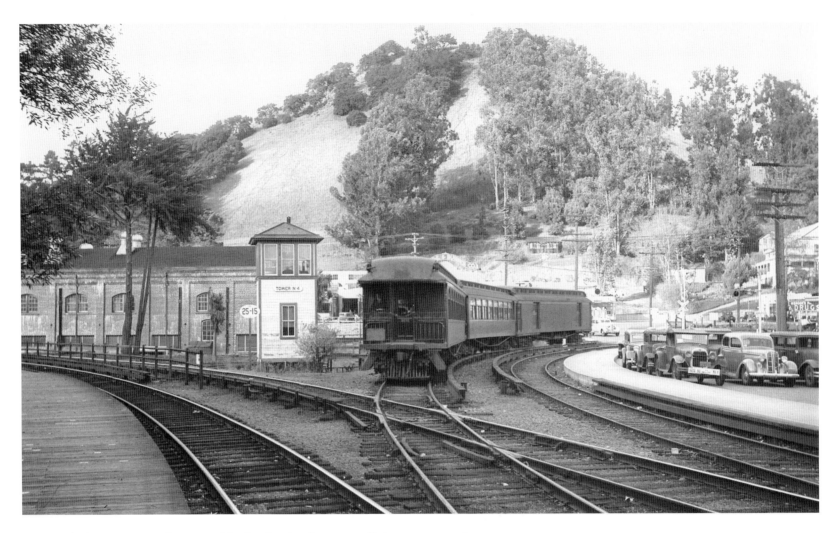

Five interlocking towers, such as tower No. 4 at San Anselmo, controlled movements at important terminals and junctions on the Northwestern Pacific. The interlocking system consisted of a series of turnouts (track switches) and signals that were set by an operator in the tower and "interlocked" so that the operator could not set up a dangerous movement before clearing a signal for a train. The operator had to align the track switches properly and set signals for opposing movements at "stop." The towers were manned 24 hours a day, seven days a week until early in the Great Depression, when rising expenses and declining patronage forced the company to eliminate "graveyard shift" jobs at all towers except San Rafael. (Courtesy Codoni collection.)

This unusual wigwag signal guarded the road that crossed the NWP main tracks at San Anselmo. (Courtesy NWPRRHS Archives.)

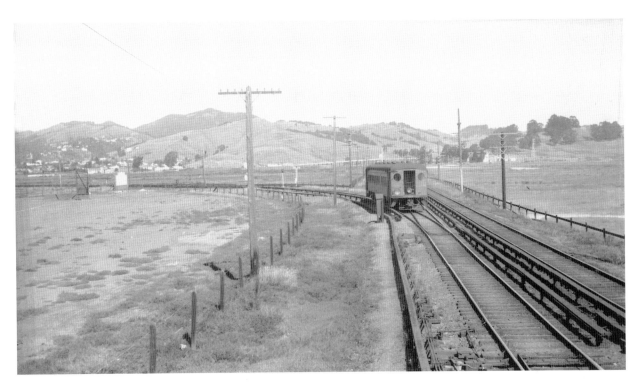

A Sausalito-bound interurban rolls off the Mill Valley Branch onto the main line in this photograph taken from tower No. 2, which controlled movements to and from the Mill Valley Branch. Trains left Mill Valley for Sausalito every 30 minutes between 5:45 a.m. and 1:18 a.m. (Courtesy the late Ted Wurm.)

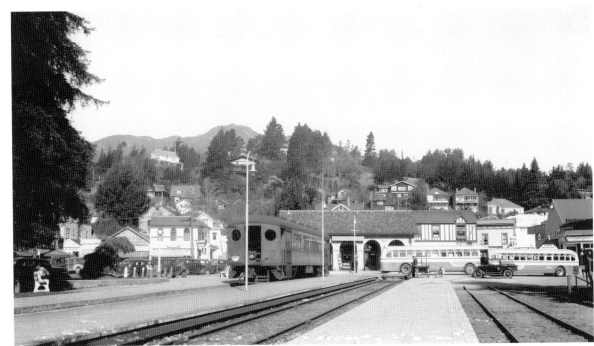

It is September 30, 1940, the last day of electric interurban service to Mill Valley. Greyhound buses that will take over the next day are waiting at the depot. (Courtesy the late Ted Wurm.)

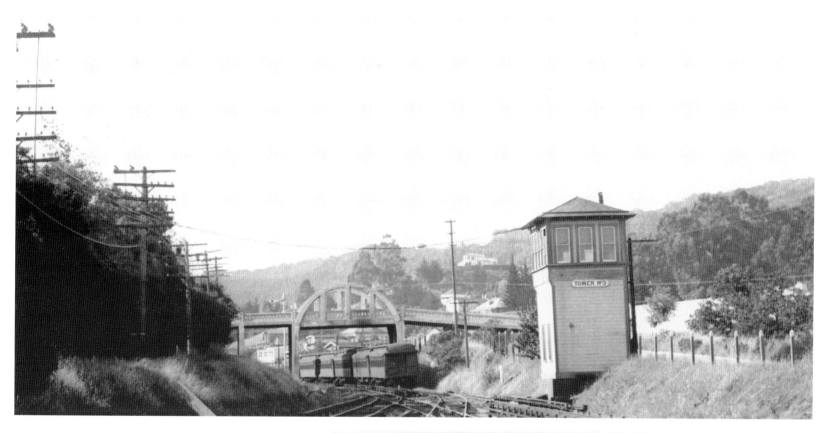

Tower No. 3 controlled the junction at Baltimore Park, between Corte Madera and Larkspur. (Courtesy NWPRRHS Archives.)

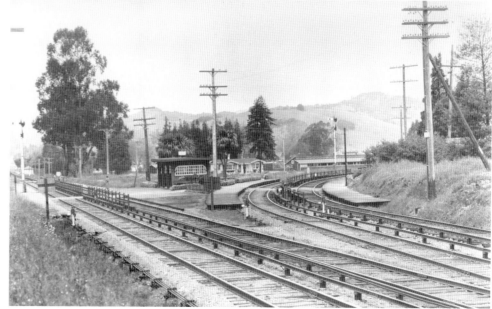

Baltimore Park was an important junction on the Northwestern Pacific electric interurban system. The line curving off to the right led to Detour, Greenbrae, and San Rafael, while the tangent track to the left went to San Anselmo and Manor. (Courtesy NWPRRHS Archives.)

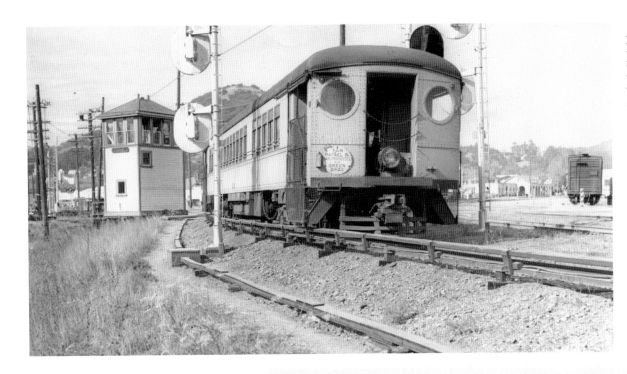

A train from Sausalito via the Cutoff heads for the San Rafael depot. Train movements into and out of the depot were controlled by the operator in Tower No. 5 (left). (Courtesy the late Charles Savage.)

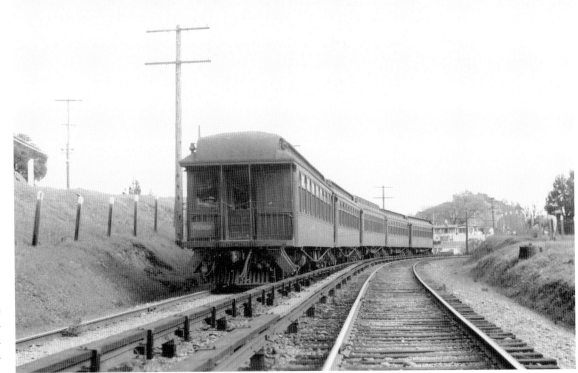

Despite impending abandonment, the right-of-way was well maintained. A five-car, rush-hour train leaving Pastori Station rounds the curve and heads into downtown Fairfax. (Courtesy NWPRRHS Archives.)

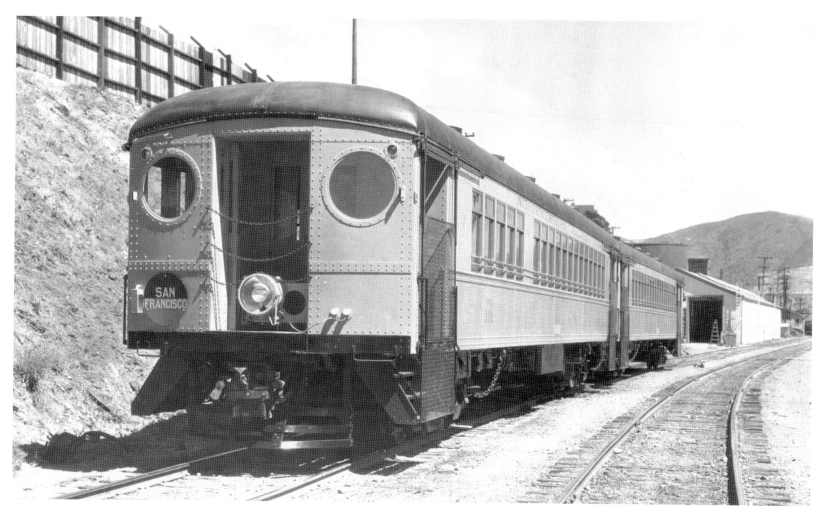

In 1929, two of NWP's new steel cars have just arrived from the builder and are at Tiburon for inspection before being taken to the electrified territory and placed into service. (Courtesy Codoni collection.)

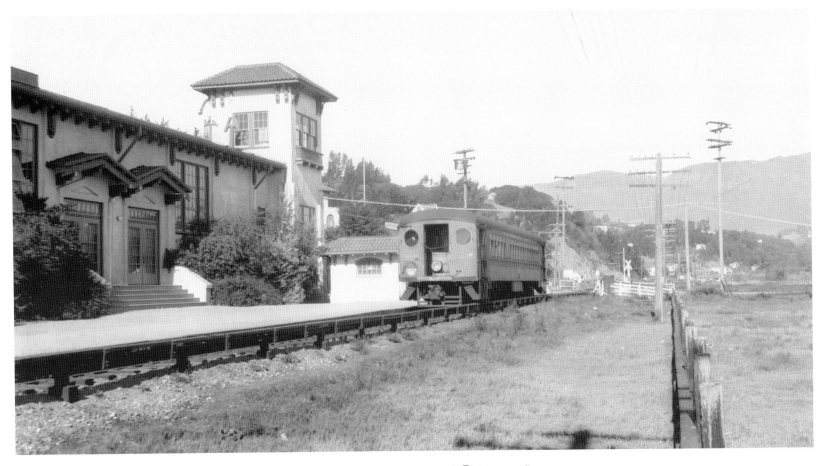

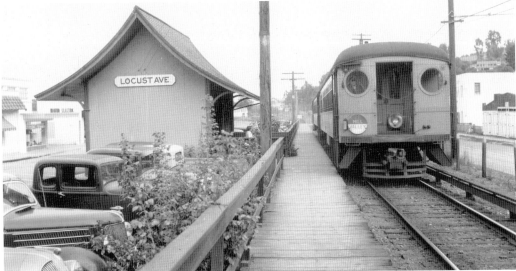

A single-car train on the Mill Valley Branch passes Tamalpais High School, en route to Sausalito. The school was also served by the "School Special," a five-car train that ran between Manor and "Tam" High every school day. (Courtesy NWPRRHS Archives.)

This two-car train stops at Locust Avenue, en route to Mill Valley. (Courtesy NWPRRHS Archives.)

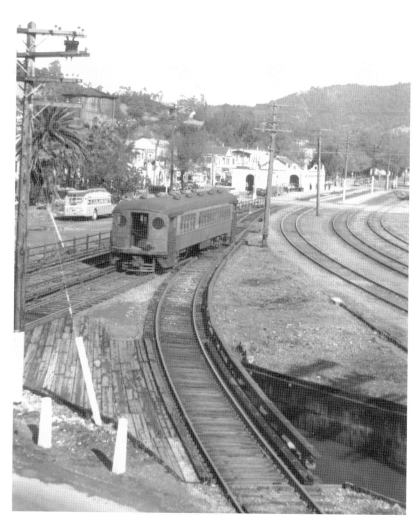

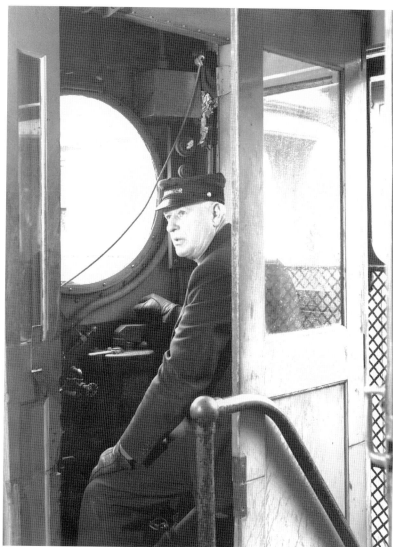

A single-car train coming from B Street heads for the San Rafael Depot (left center), northern terminus of the electric interurban service. The tracks at right served steam trains. (Courtesy Ted Wurm.)

This engineer is at the controls of a NWP's steel interurban preparing to leave San Rafael with one of the last trains. (Courtesy NWPRRHS Archives.)

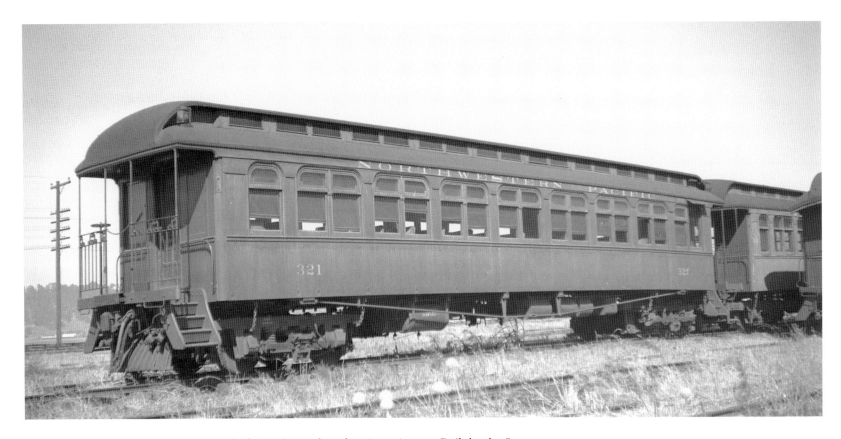

This open-platform motorcar was typical of NWP's wooden, electric equipment. Built by the St. Louis Car Company in 1902, it served until the abandonment of interurban service on February 28, 1941. (Courtesy Codoni collection.)

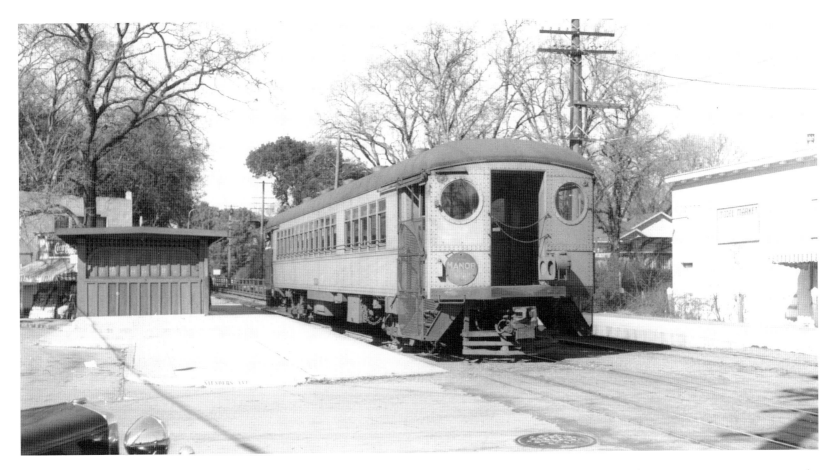

A single-car train pauses at Yolanda Station on the San Anselmo–Manor line. (Courtesy the late Charles Savage.)

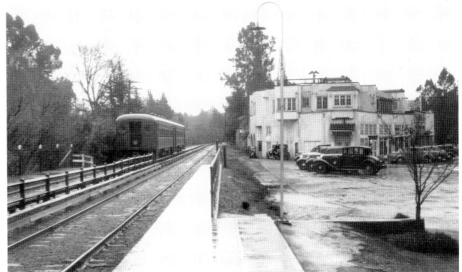

This was the last day, February 28, 1941, of NWP's Marin County interurban service. The weather was appropriately gloomy as Ted Wurm snapped this photograph of one of the last trains approaching Ross Station. (Courtesy the late Ted Wurm.)

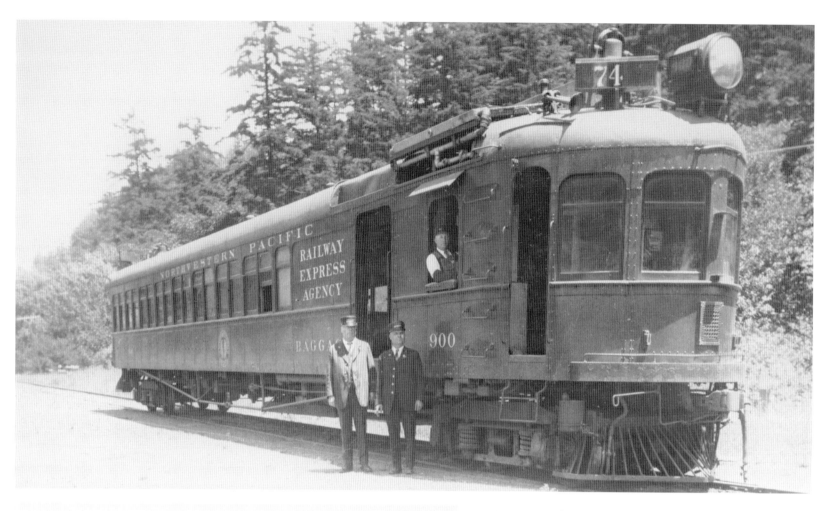

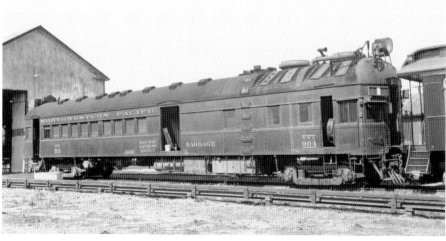

NWP gas-electric No. 900 is stopped at Lagunitas with Train No. 74, the Manor-Lagunitas passenger train. The crew consists of an engineer, conductor, and brakeman—two fewer crewmembers than needed on a steam train. The engineer's compartment was several feet back from the front of the car, making it difficult for him to see the track ahead without leaning out the window. (Courtesy NWPRRHS Archives.)

In 1930, the Brill Company produced NWP No. 904 and sister No. 903. At 173,820 pounds, they were the heaviest NWP diesel-electrics and were powered by four 300 horsepower motors. They had baggage facilities and seated 34 passengers. The small passenger capacity was not a handicap because these cars were designed to haul trailers. (Courtesy NWPRRHS Archives.)

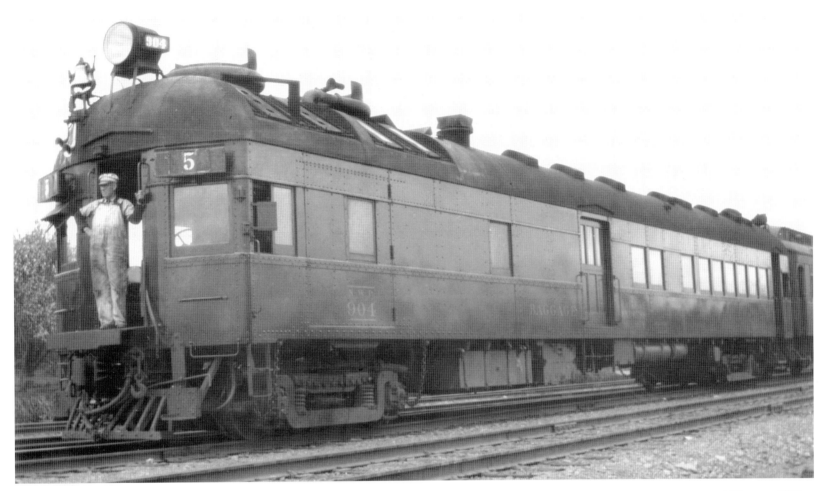

Train No. 5 with NWP diesel-electric No. 904 is in a siding, waiting for an eastbound train. (Courtesy Codoni collection.)

The clock on the building at far right shows 2:32 p.m., and the engineer is looking back for his starting signal to move Train No. 5 out of San Rafael on the remainder of its journey from Ukiah to Sausalito. With retrenchment of passenger service in the mid-1930s, No. 903 and sister No. 904 went into service on the Sausalito-Eureka day trains (Nos. 1 and 2). Note the protected third rail for electric interurban trains under the platform of left-hand track. (Courtesy Codoni collection.)

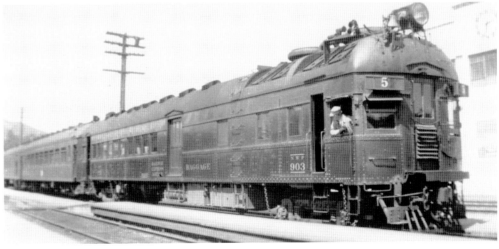

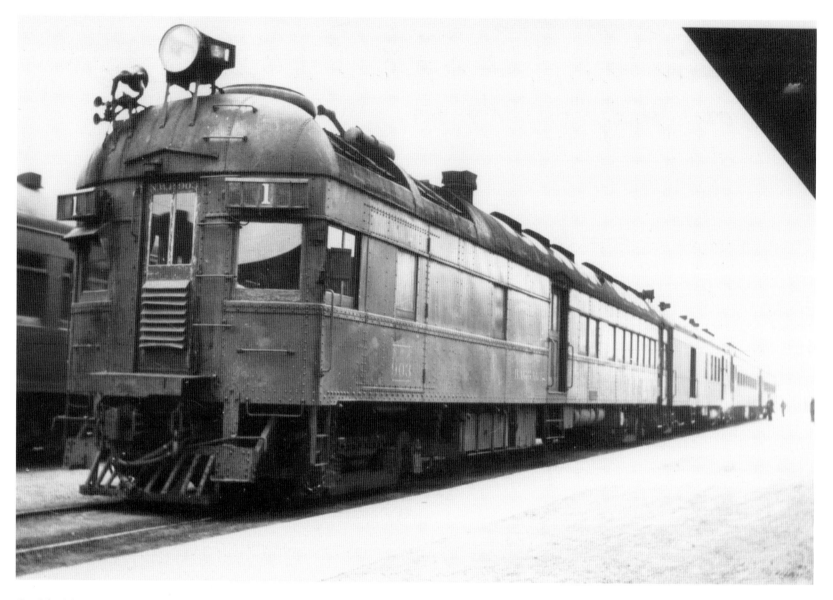

On July 15, 139, Train No. 1 is ready to leave Eureka behind diesel-electric No. 903. (Courtesy the late Ed Nervo.)

OPPOSITE: *Eureka* was the largest passenger ferry on the bay, and she made her last NWP ferry trip in 1941. She then went to the Southern Pacific for the San Francisco–Oakland run, ending her career with a cracked crankshaft in 1955. She is on exhibit at the San Francisco Maritime National Historical Park. (Courtesy Trimble collection.)

FERRIES TO SAN FRANCISCO

San Francisco is located on the tip of a peninsula, surrounded by San Mateo County to the south, the Pacific Ocean to the west, and San Francisco Bay to the north and east. Until the completion of the bridges that span the bay, the ferries were indispensable to transbay travel.

Significantly, no less than six corporate antecedents of the NWP—Sausalito Land & Ferry Company, San Rafael & San Quentin Railroad, San Francisco & North Pacific Railway, North Pacific Coast Railroad, North Shore Railroad, and California Northwestern Railroad—had ferry services to San Francisco. As years of corporate mergers culminated in the creation of the Northwestern Pacific Railroad in 1907, one result was a fleet of ferries of varied descriptions such as converted riverboats, a small launch, freight railcar ferries, passenger ferries, single-end and double-end vessels, steam powered sidewheelers and sternwheelers, and finally, diesel-electric ferries specifically for automobiles.

Lastly let us not forget the NWP's tugboat *Tiger*, a sidewheeler that manipulated barges loaded with freight cars around San Francisco Bay. No less than the railroad itself, the NWP's navy meant variety..

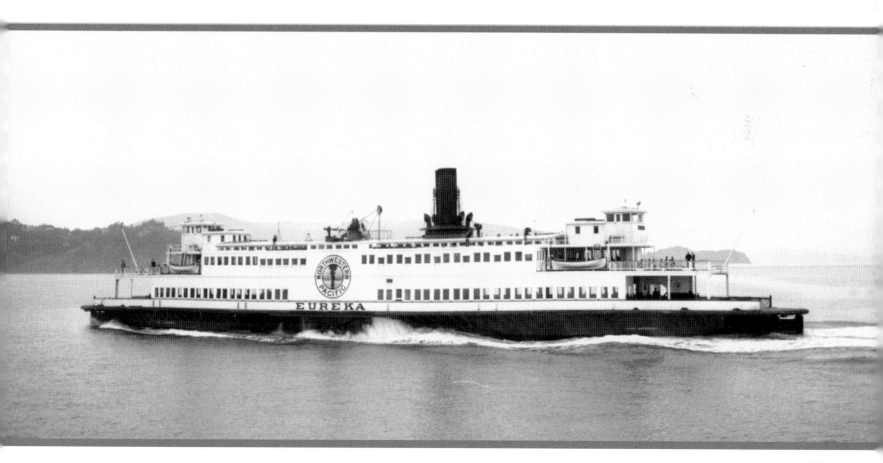

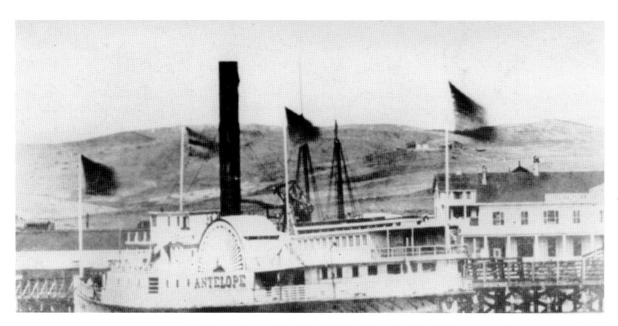

Antelope made history. Built in 1847 as a Long Island excursion boat, she steamed to California during the gold rush to work the Sacramento River. *Antelope* brought the first Pony Express mail from Sacramento to San Francisco on April 15, 1860, and carried enough gold for Wells Fargo to be dubbed the "Gold Boat." She worked the San Francisco & North Pacific's Petaluma Creek run from July 9, 1871, until retirement in 1888. (Courtesy Trimble collection.)

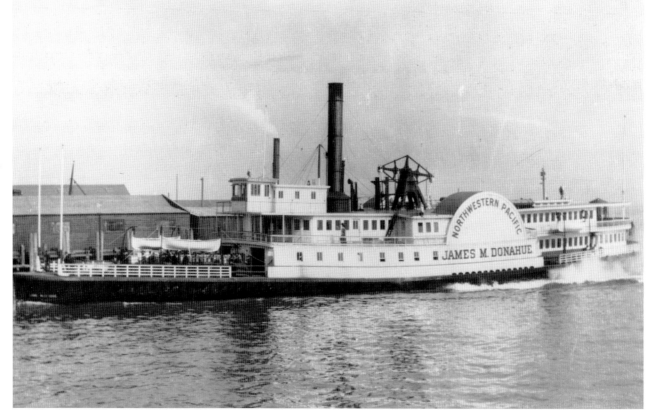

The artful eye and camera of the late Wilbur C. Whittaker preserved this photograph of the *James M. Donahue* in NWP livery. The ferry, named for the son of Peter Donahue, was single ended and therefore slower crossing the bay than double-end ferries, since it had to be backed out of the slip and turned before proceeding. The elder Donahue was the pioneer builder of the San Francisco & North Pacific Railway. (Photograph by the late Wilbur C. Whittaker; courtesy Trimble collection.)

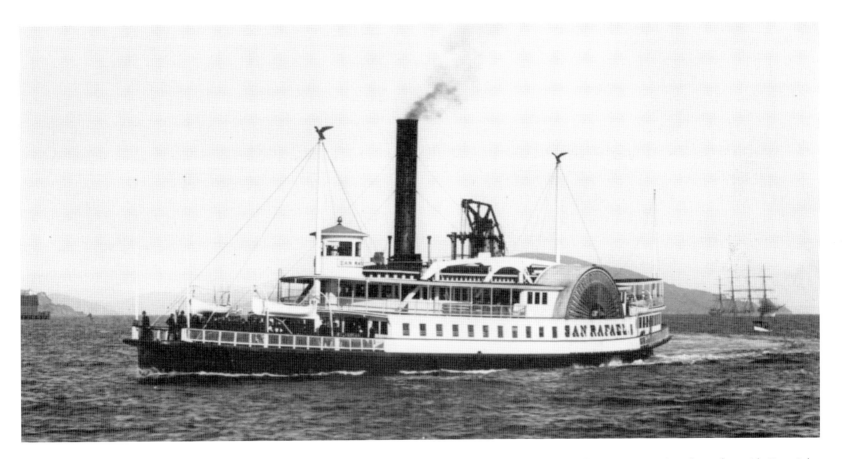

On November 30, 1901, at 6:10 p.m., *San Rafael* left San Francisco in a dense fog, with Capt. John T. McKenzie at the wheel. Abreast of Alcatraz Island, she was rammed amidships by the *Sausalito* and sunk with a loss of three lives. This incident was the inspiration for Jack London's novel *The Sea Wolf.* (Courtesy Codoni collection.)

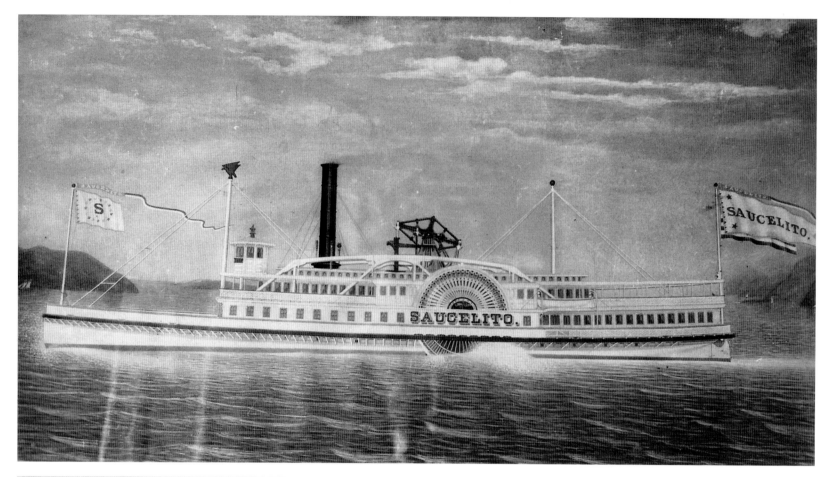

Saucelito was a sister ship to *San Rafael*, both owned by the North Pacific Coast Railroad. Built in 1877 in New York, she was destroyed by fire on February 25, 1884. (Courtesy NWPRRHS Archives.)

Lagunitas wasn't built for looks; she was built for work, hard work. Launched in 1903 in Alameda for the North Shore Railroad, her job was to move narrow-gauge freight cars between Marin County and San Francisco. In 1908, she was converted to standard gauge. *Lagunitas'* wooden hull was not copper sheathed, and she suffered early disintegration. In 1917, her brief life ended. (Photograph by W. A. Silverthorn; courtesy Codoni collection.)

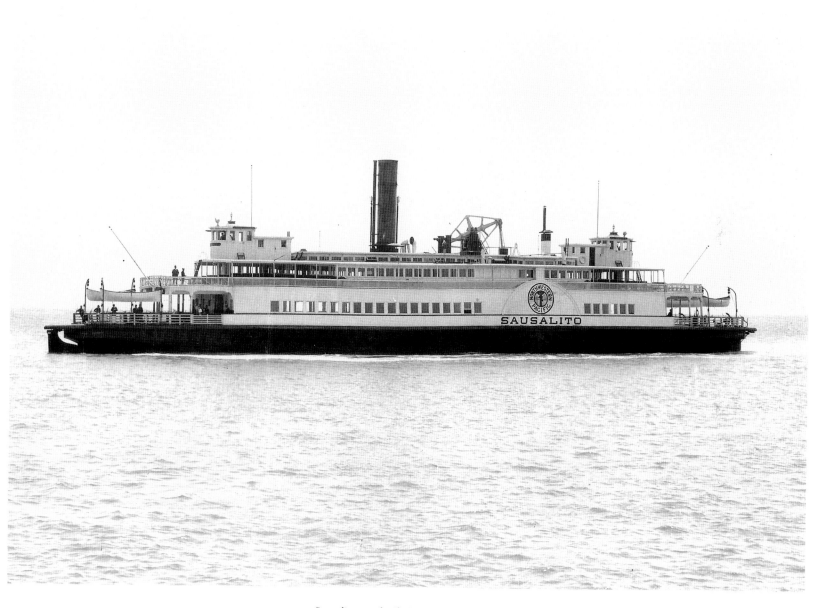

Sausalito was built in 1894 as a combination passenger ferry and car float for NPC narrow-gauge freight cars. In 1901, she accidentally rammed and sunk the *San Rafael*. Alert work by the two crews limited the loss of life to only three people. (Courtesy NWPRRHS Archives.)

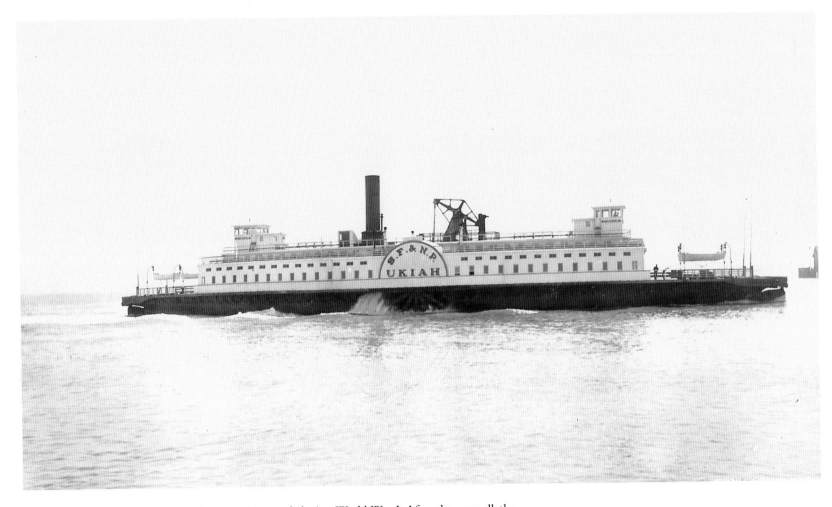

The American railroads came under federal control during World War I. After the war, all the worn-out railroad equipment had to be replaced at government expense. The NWP ferry *Ukiah* was so badly used that she had to be almost completely rebuilt, emerging from the shipyards as *Eureka*. (Courtesy NWPRRHS Archives.)

Increased rail-ferry traffic and population meant that different wharfs for ferry business were no longer adequate in the 1870s. In 1875, this ferry shed at the foot of Market Street in San Francisco was constructed. Almost immediately, street railway lines terminated at this juncture, making it the city's major transit hub until 1939. (Courtesy Trimble collection.)

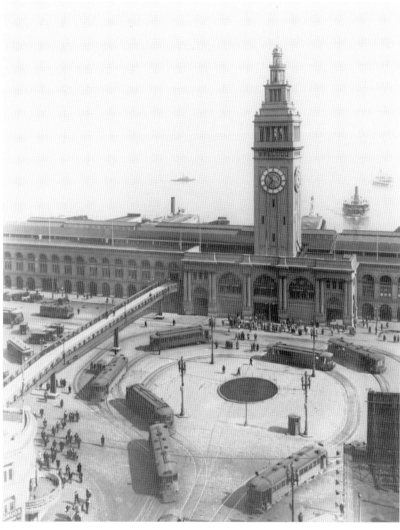

By the 1890s, an even newer and more efficient ferry landing was needed in San Francisco. Thus the Ferry Building was built and opened in 1898. During the 1920s and 1930s, this was the world's second busiest passenger terminal, hosting some 55 million patrons a year—exceeded only by London's Charing Cross Station. (Courtesy Trimble collection.)

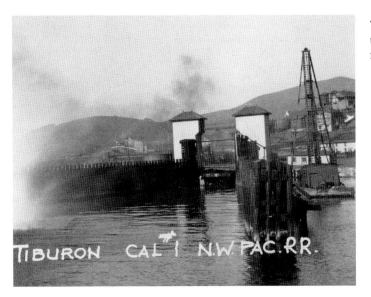

The freight slip at Tiburon operated much the same as the passenger slip except that the apron had rails, allowing the freight cars to roll on and off the main deck of the ferry, which also had rails on its deck. (Courtesy NWPRRHS Archives.)

Amador was borrowed from the Southern Pacific from time to time when vacationers and excursionists taxed the NWP fleet to the limit. Built in 1869 as a Sacramento River boat, she was rebuilt in 1878 into the double-end ferry pictured here. (Courtesy Trimble collection.)

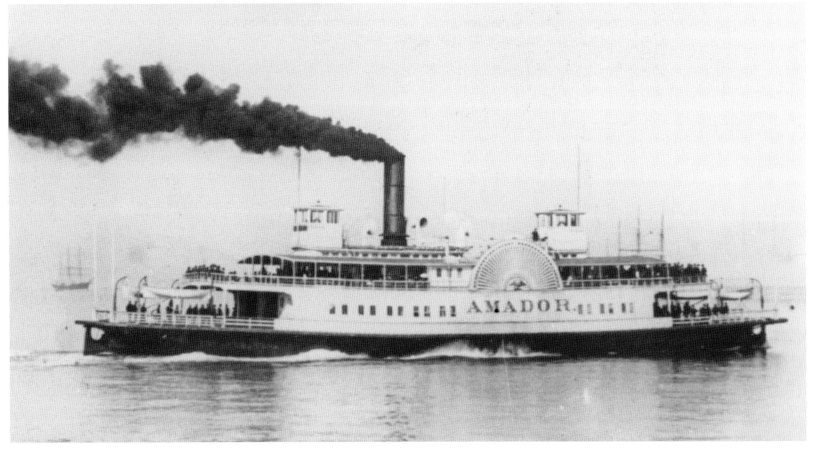

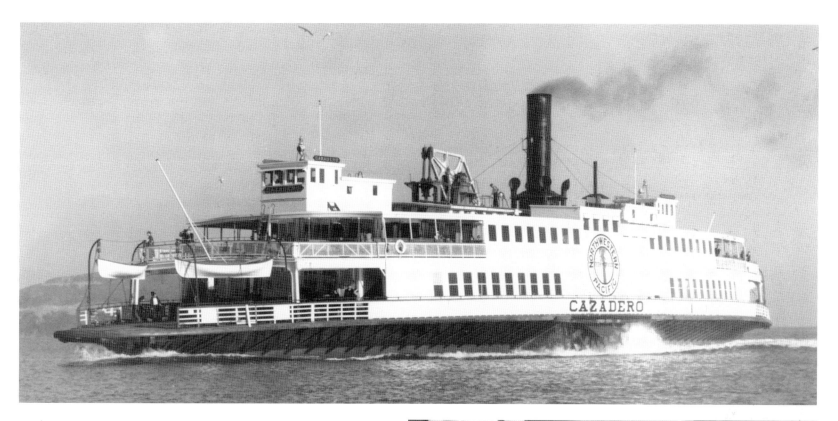

Cazadero was launched in 1903, listing to port. Around 600 tons of ballast, made from railroad scrap iron and cement, were added to her hull, increasing the boat's draft, but reducing the speed. In 1942, *Cazadero* was scrapped. (Courtesy Codoni collection.)

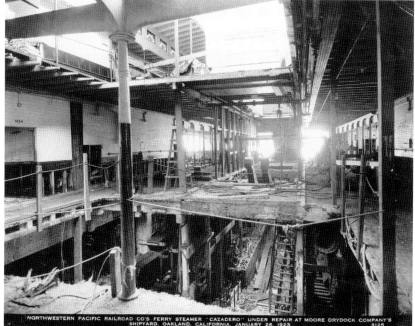

In the early 1920s, the walking beam machinery in *Cazadero* went amok, slicing a huge gash in her superstructure. This photograph of her rebuilding shows a dissection of a ferryboat, a rare view of ferry architecture. (Courtesy NWPRRHS Archives.)

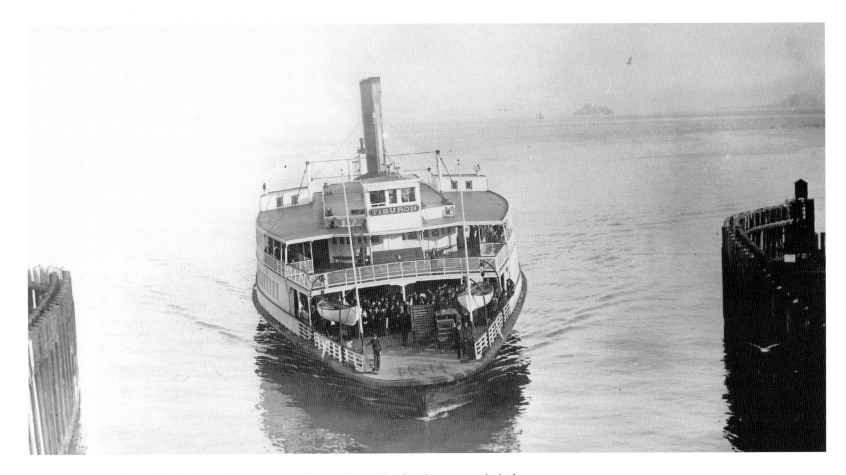

Tiburon's captain has ordered the engineer to cut the engine as the handsome vessel drifts toward the Sausalito slip. Next the engineer will reverse the engine to reduce the ferry's impact against the pilings and the deckhands will tie her up so the passengers can depart. (Courtesy NWPRRHS Archives.)

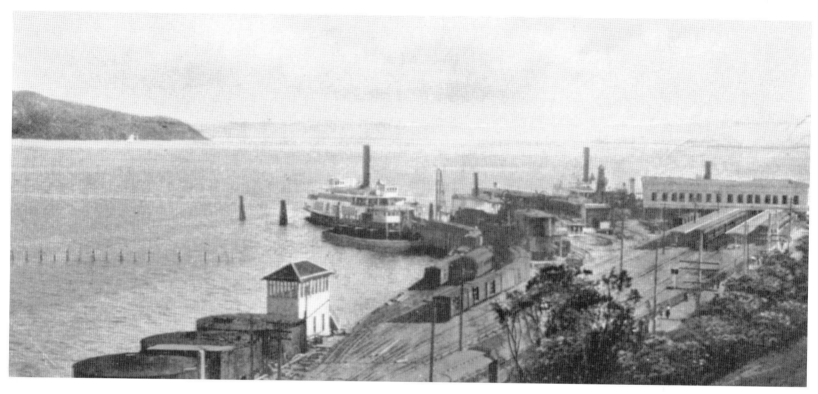

The old NPC ferry and railroad terminal at Sausalito was razed in 1902 by the North Shore Railroad as one of its many improvements. To the left is the slip for railroad car ferries; to the right are slips for the passenger ferries. (Courtesy NWPRRHS Archives.)

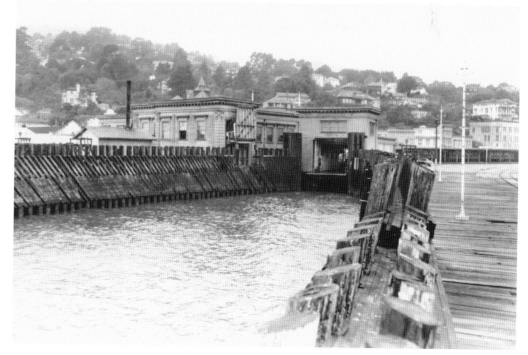

This photograph is the waterside view of the later passenger ferry slip at Sausalito. Once the deckhands had secured the vessel, passengers walked off the main deck, over an apron, through the building, and out to their train connections. (Courtesy Trimble collection.)

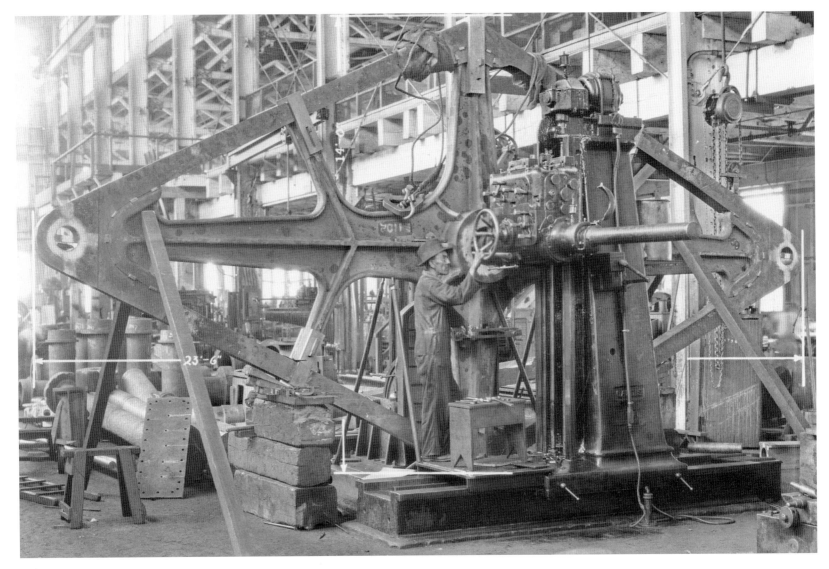

A machinist works on the new walking beam for the *Eureka* at Moore Drydock Company in Oakland on July 19, 1926. Dimensions marked on the photograph indicate that the beam was 23.5 feet wide and 14 feet high. (Courtesy Trimble collection.)

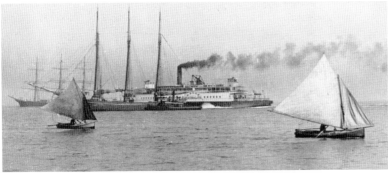

Sausalito steams between a pair of schooners on yet another 30-minute voyage between San Francisco and her namesake city. In the foreground is a pair of lateen sail feluccas, mainstays of the bay's Italian fishing fleet. (Courtesy Trimble collection.)

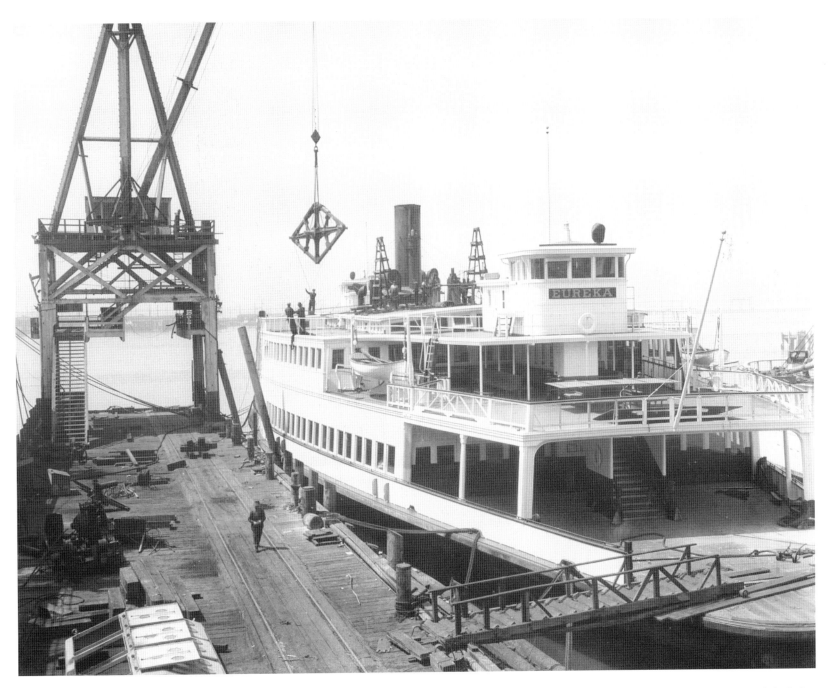

The walking beam on a steamer was connected to the piston on one end and the crankshaft that turned the paddlewheels on the other. This 1926 photograph shows *Eureka's* new walking beam being installed at Moore Drydock Company in Oakland. (Courtesy Trimble collection.)

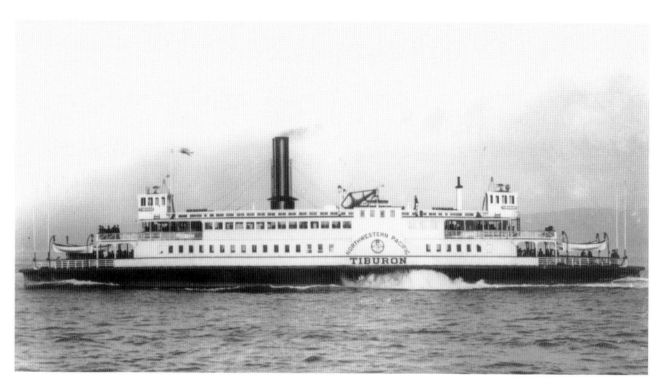

Tiburon, built in 1884 for the SF&NP, was 240 feet long, could carry 1,500 passengers, and was noted for her speed. Ferryboat racing was frowned upon by management and owners, and any captain caught racing was given demerits—double demerits if he lost the race! (Courtesy Trimble collection.)

Tamalpais II was launched by the Union Iron Works of San Francisco in 1901, replacing *Tamalpais I.* As built, she was unable to make her designed speed despite her 2,100 horsepower engine. Her builders took her back and added 15 feet to each end, which corrected the problem. She was the only steel-hulled, double-end passenger vessel in the NWP fleet. Richard Wosser, son of the chief engineer of the *Princess,* was *Tamalpais II's* chief engineer, and his son Lawrence was first assistant engineer on the *Eureka.* (George H. Harlan photograph; courtesy Codoni collection.)

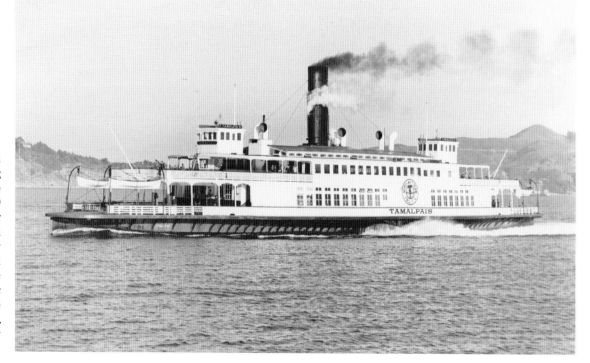

Requa was reputed to have been millionaire miner Mark Requa's private yacht. Built in 1909, the NWP purchased it that same year for the Sausalito–Belvedere–Tiburon service. In 1911, she burned to the water line and was rebuilt into the *Marin*. (Courtesy Codoni collection.)

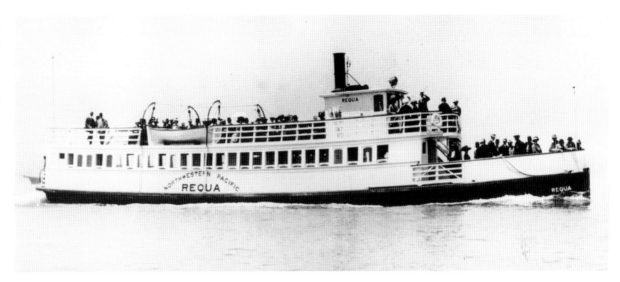

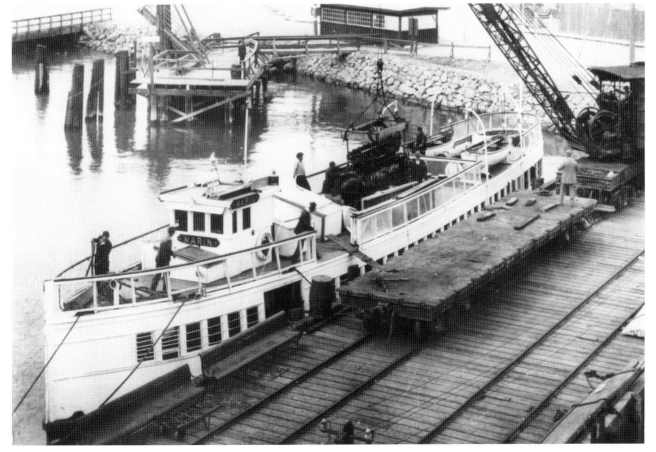

The smallest of NWP's ferries was the *Marin*, which shuttled passengers between Sausalito, Belvedere, and Tiburon. Here she is docked at Tiburon, while shop forces install a six-cylinder standard gasoline engine. The building in the background was the shelter for ferry passengers. (Photograph by Mike Guilholm; courtesy Codoni collection.)

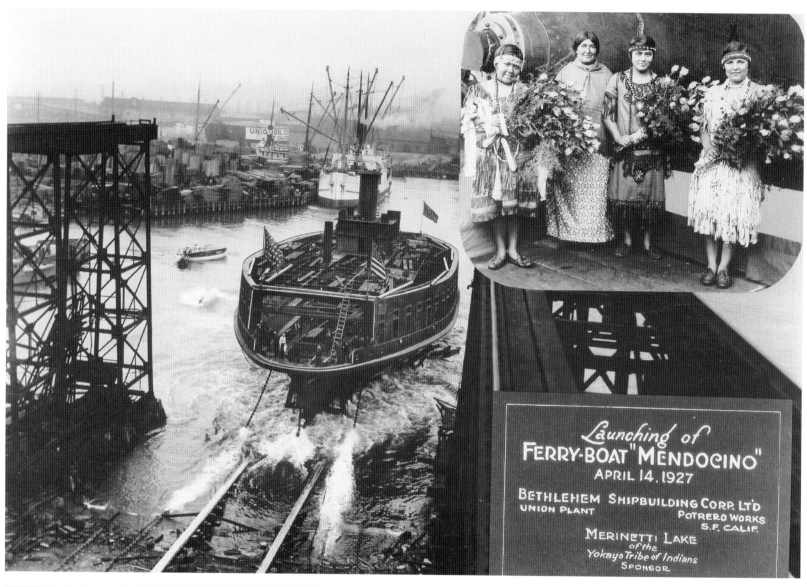

Launching of
FERRY-BOAT "MENDOCINO"
APRIL 14, 1927

BETHLEHEM SHIPBUILDING CORP. LT'D
UNION PLANT POTRERO WORKS
S.F. CALIF.

MERINETTI LAKE
of the
Yokayo Tribe of Indians
SPONSOR

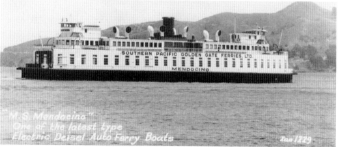

"M.S. Mendocino"
One of the latest type
Electric Deisel Auto Ferry Boats

The 1927 launching of the *Mendocino* gave the NWP not only its first all-automobile ferry, but its first diesel-electric vessel as well. This was in response to Golden Gate Ferries' auto ferry run from San Francisco's Hyde Street Pier to Sausalito—a shorter and faster trip than NWP's run from the Ferry Building. (Courtesy NWPRRHS Archives.)

Mendocino and her sister ships, *Redwood Empire* and *Santa Rosa*, were steel-hull, diesel-electric vessels built in 1927 to carry automobiles and had none of the charm of the older ferries. In 1929, all three went to Southern Pacific-Golden Gate Ferries. (Courtesy Trimble collection.)

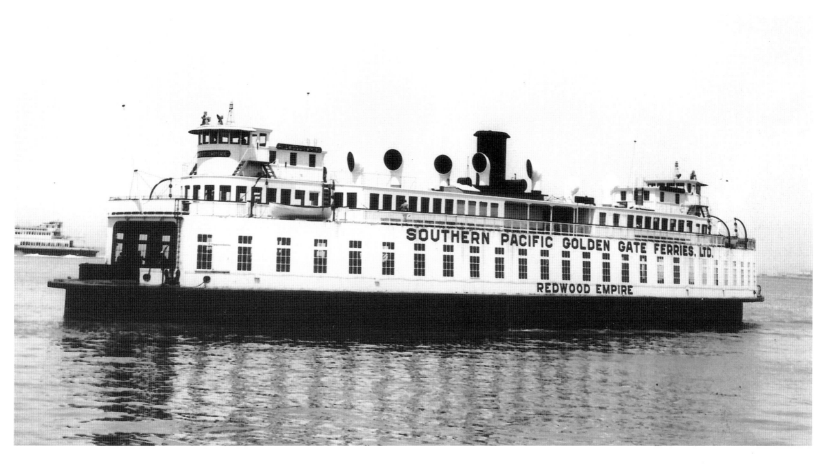

The NWP resisted improving auto-carrying services, believing that it took business away from trains. When the three auto ferries were built, it was too little too late, as the public by now preferred the rival Golden Gate Ferries. (Courtesy NWPRRHS Archives.)

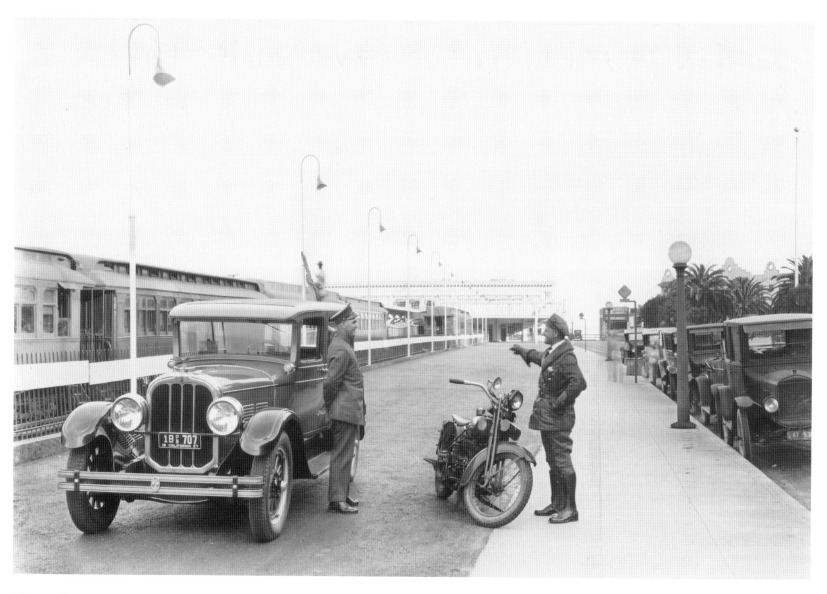

The regular NWP passenger boats also carried automobiles, which proceeded along this road and boarded the boats at the ramp in the far distance. In this 1927 photograph, a Sausalito policeman appears to be giving directions to the driver of this shiny automobile. (Courtesy NWPRRHS Archives.)

OPPOSITE: California Northern operated freight trains on the NWP under lease, using its own handsomely painted green, white, and yellow trimmed locomotives from 1993 until 1996, when the entire NWP became publicly owned. Pictured here in June 1996 is California Northern No. 113 at Petaluma. (Photograph by Paul C. Trimble.)

INTO PUBLIC OWNERSHIP

The story of the lengthy and piecemeal transition of the NWP from private to public ownership is far too detailed and complicated to record here, and yet a brief synopsis is definitely in order.

Ironically for the NWP, freights generating good revenue originated on the North End, a segment that was more expensive to maintain than any other in the United States. Yet by the 1970s, it was doubtful if the South End could stand by itself without the North End as a feeder. As with any railroad, parent Southern Pacific had long been willing to prune its financially hopeless branches and subsidiary lines, and by now, the NWP had become ripe for potential abandonment.

In 1984, the SP sold the North End to Bryan Whipple, who ran it as the Eureka Southern (EUKA). For all of Whipple's heart and energy, EUKA was in bankruptcy within a few years. In 1992, EUKA was sold to a public agency, the North Coast Railroad Authority (NCRA) and became the North Coast Railroad. Meanwhile the Golden Gate Bridge Highway and Transportation District (GGBHTD) had begun purchasing sections of NWP's South End.

On September 30, 1992, the SP merged what remained of the NWP into the parent road, and in 1993 leased the portion from Suisun to Willits to the California Northern Railroad Company. After protracted negotiations, the old NWP south of Willits was sold on April 30, 1996, to a consortium composed of the GGBHTD and Marin and Sonoma Counties. It was then fused with the North Coast Railroad to form the new NWP under the overall direction of the NCRA.

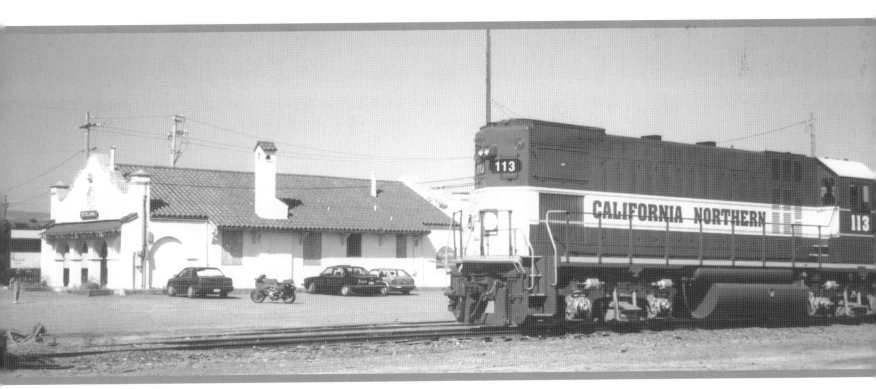

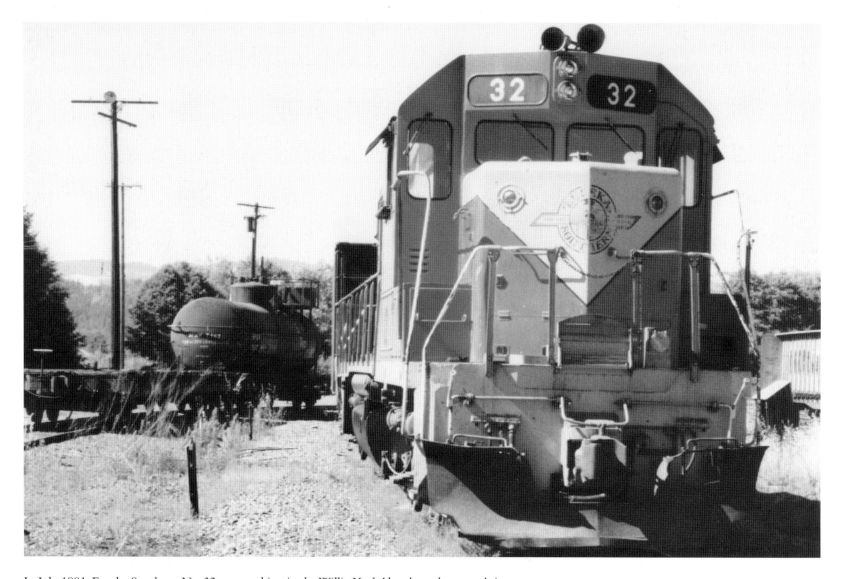

In July 1991, Eureka Southern No. 32 was working in the Willits Yard. Already on borrowed time, EUKA was beleaguered by a lack of freight carloads, plus winter damage in the Eel River Canyon, the NWP's old nemesis. On November 12, a bankruptcy court ordered EUKA be sold to the North Coast Railroad Authority for $5.2 million. (Photograph by Paul C. Trimble.)

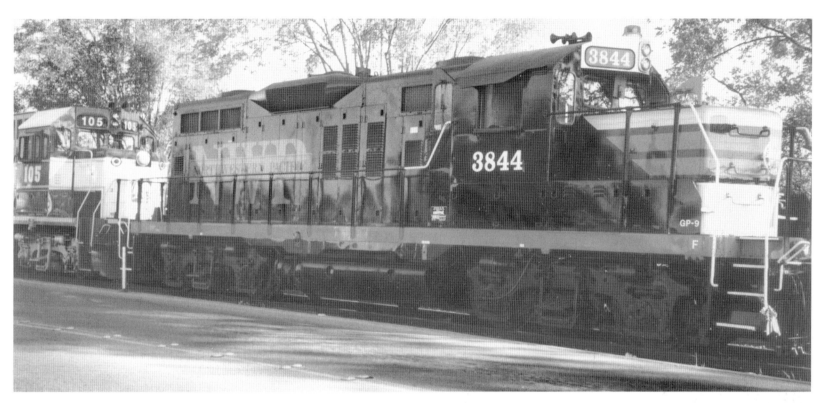

The "new," or publicly owned, Northwestern Pacific began life at 12:01 a.m. on April 30, 1996, using rebuilt EMD GP9s painted in the SP "Black Widow" motif, with the initials on the sides in orange. On June 15, 1996, Train No. 3844 was coupled to California Northern No. 105 for the second leg of the Celebration Special, commemorating the railroad's reopening, at Petaluma. (Photograph by Paul C. Trimble.)

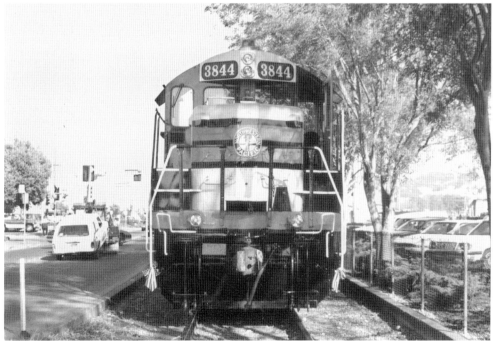

On the nose of the NWP locomotives was the traditional NWP logo, dating back to 1910. Train No. 3844 was only minimally decorated for the Celebration Special. Merely the appearance of a working railroad with the name Northwestern Pacific was enough to satisfy the public. (Photograph by Paul C. Trimble.)

Much deferred maintenance would have to be overcome before the NWP could carry passengers at a competitive speed. For the Celebration Special, the railroad borrowed rolling stock from California Western ("Skunk Train"), a private owner, and Southern Pacific, whose business car, *Sunset*, brought up the rear. (Photograph by Paul C. Trimble.)

Among those invited aboard the Celebration Special was Ruth Rockefeller of Willits, the tireless and relentless advocate for the NWP, and an NCRA director. To the NWP's supporters and employees, she was their Deborah, Boadicea, Matilda of Tuscany, and Isabella of Castille all rolled into one. With her at Healdsburg was NWP general manager Dave Hebert. (Photograph by Paul C. Trimble.)

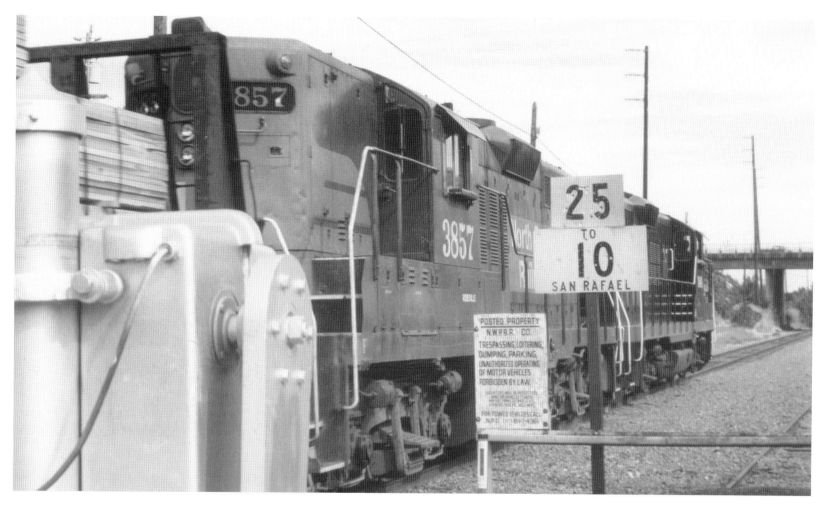

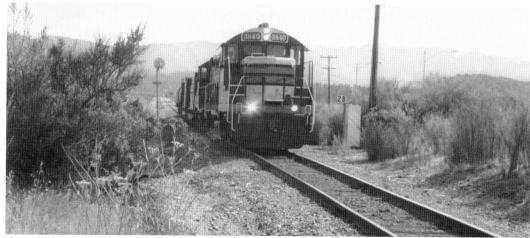

Pictured above, on July 22, 1996, the first revenue freight of the publicly owned NWP rolled outbound to Schellville, led by NWP No. 3840 and ex–North Coast Railroad No. 3857. Milepost 25 in Novato is a reminder of the days when the NWP mileposts began at San Francisco's Ferry Building. At Milepost 28 near the Petaluma River Bridge, pictured at right, Extra 3840 polishes the rails en route to Schellville. Open space is not hard to come by in environmentally conscious Marin County, but a working railroad is, and two locomotives and three cars were better than no trains at all. (Both photographs by Paul C. Trimble.)

NORTHWESTERN PACIFIC RAILROAD

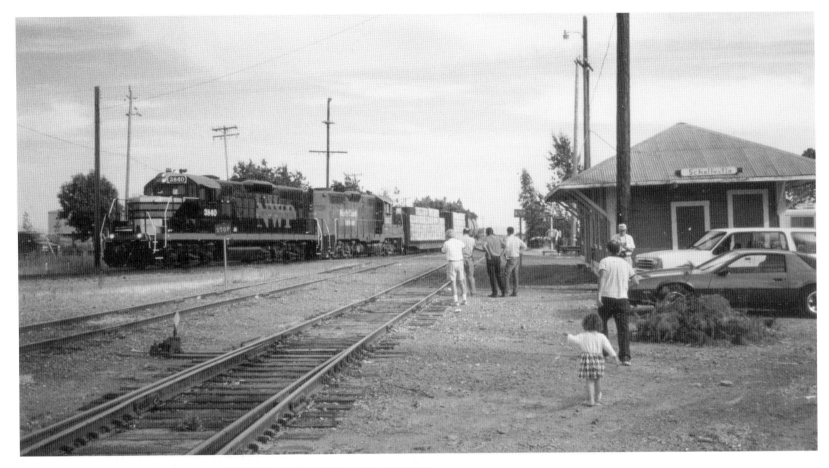

No. 3840 East backs into the Schellville Yard delighting several railfans, including NWP loyalist Michael Pechner with his daughter (right foreground). This was once the NWP-SP interchange where scores of carloads of lumber rolled, rather than the mere two on this train. (Photograph by Paul C. Trimble.)

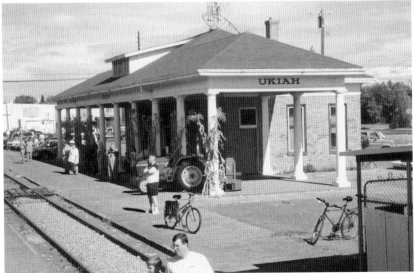

Passenger service, albeit in the form of excursion trains between Healdsburg and Willits, returned to the NWP in October 1996 using NWP locomotives and former Southern Pacific Daylight coaches. Members of the Northwestern Pacific Railroad Historical Society acted as car attendants. Locals greeted the train at Ukiah. (Photograph by Paul C. Trimble.)

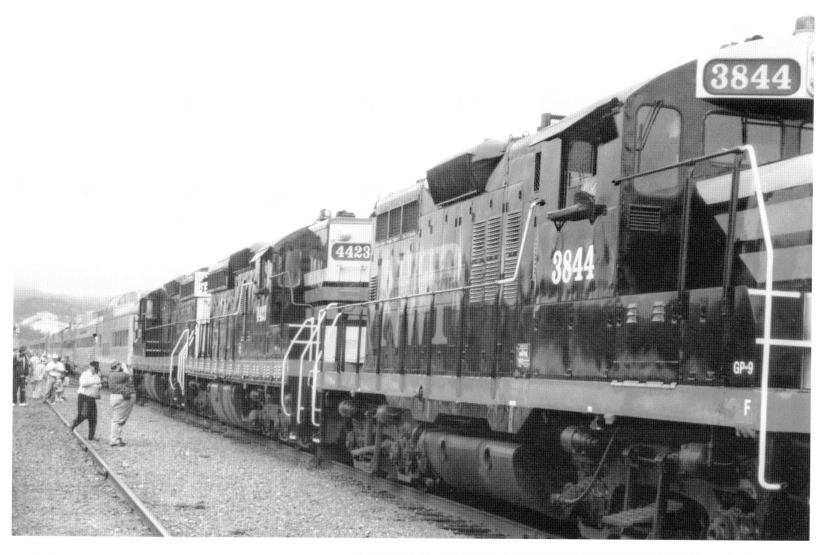

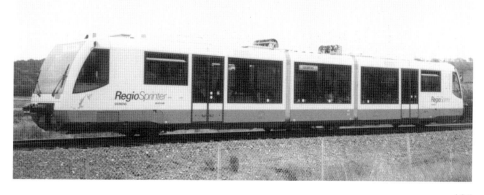

Ready for the return trip to Healdsburg, a trio of EMD GP9s from the NWP (Nos. 3844, 4423, and 4327) couple to an odd assembly of dome cars from Union Pacific and Southern Pacific, together with *Daylight* coaches, on Columbus Day in 1996. (Photograph by Paul C. Trimble.)

Ever-increasing automobile traffic on a narrow corridor offered one rationale for public ownership of the NWP and, as of this writing, hopes are high for a rail commuter line on the right-of-way. On December 10, 1996, a Siemens Transportation Systems, Regio Sprinter, made a demonstration appearance on the NWP. (Photograph by Fred Codoni.)

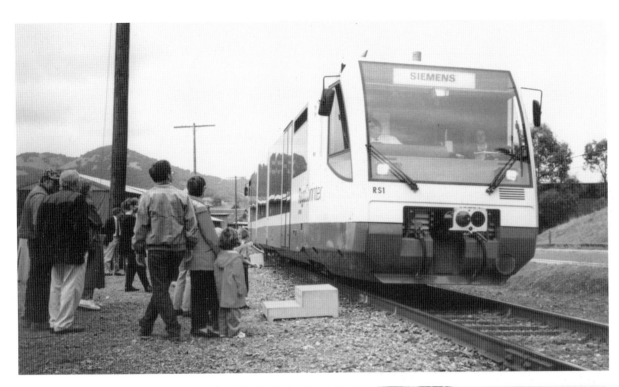

There's just something about a train, even if it is a diesel powered, German-built, modern, rapid-transit vehicle in Novato for exhibition purposes only. Whether out of curiosity or out of hope that the NWP can provide relief from commuter traffic, the Regio Sprinter did attract visitors. (Photograph by Fred Codoni.)

Hopes remained high for the NWP in 1997, as a local television station broadcast a special on the railroad on June 9, using equipment from the excursion train. During a stop at Hopland, author Fred Codoni chatted with NWPRRHS secretary Lynn Fostine, daughter of the late NWP trainmaster, Jerry Fostine. (Photograph by Paul C. Trimble.)

Despite the initial optimism, the NWP was again forced to shut down, a victim of recurring winter damage, promised relief funding that failed to materialize, opposition from highway interests, and choking regulations. As repair work proceeded on November 13, 1999, at Olive Avenue in Novato, the sky was gloomy. The crossing gate blocking the rails instead of the street did not bode well for the new millennium. (Photograph by Paul C. Trimble.)

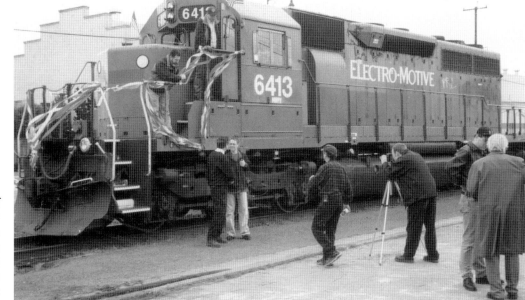

As the new millennium dawned, the credo of the railroad seemed to be "no surrender." A new locomotive was decorated for a "Return to Service Ceremony" in Petaluma on February 16, 2001, but in fact, freight service never truly resumed. The best hope at present is for a commuter service between Cloverdale and Larkspur, with freight to follow. (Photograph by Paul C. Trimble.)

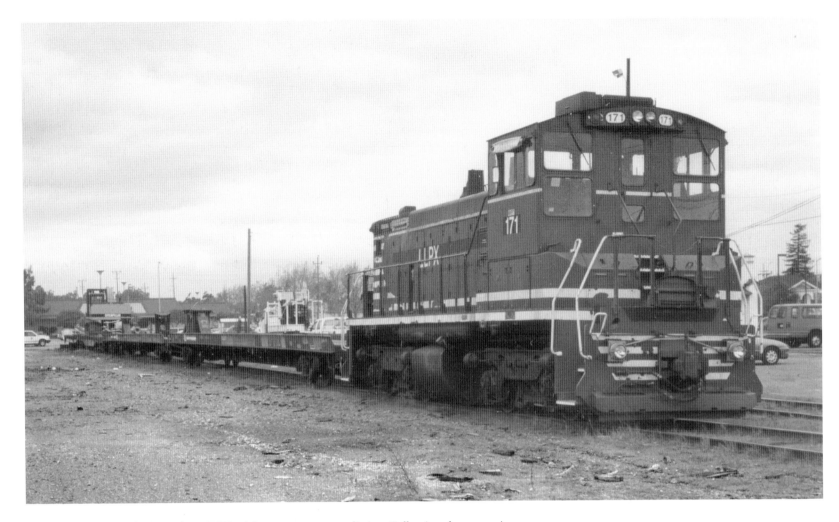

"Nowhere in Particular" was the NWP's nickname, never a prediction. Following the reopening, the Federal Railroad Administration shut down the NWP north of Petaluma and still had not provided inspection of the repairs between Windsor and Willits. Locomotive No. 171, an EMD SW1500 with reporting marks "NWPY," sits in Petaluma on February 16, 2001. *Quo vadis*, NWP? (Photograph by Paul C. Trimble.)

OPPOSITE: CWR No. 44, built by Baldwin in 1930, came to the Redwood Route in 1944 from Lamm Lumber Company in Oregon. The 2-8-2 lasted only until 1952. With diesel locomotives arriving in 1949, it seemed as if steam on the CWR was gone for good. It only seemed that way! (Courtesy Trimble collection.)

JUNCTIONS

Just as the NWP was an amalgamation of 42 railroads and franchises, its operations were met and supported by numerous independent lines, plus one subsidiary line, as diverse as the NWP itself once was—or more so. Roads were as short as the 1,500-foot-long Fairfax Incline and as long as the 37.09 miles of the Petaluma & Santa Rosa Railroad. Track included 2-foot; 3-foot; 3-foot, 6-inch; and even 3-foot, 9-inch gauges, as well as standard gauge! They were powered by steam, distillate, electricity, horses, and mules, and carried everything from passengers at 5¢ a ride to mine and forest products.

This chapter's sampling of some of these pikes is by no means a complete listing. They were far too numerous to include here and, unfortunately, were seldom photographed. While these railroads were not part of the NWP, per se, they were nevertheless part and parcel of North Coast railroading and in most cases acted as feeders to the main line.

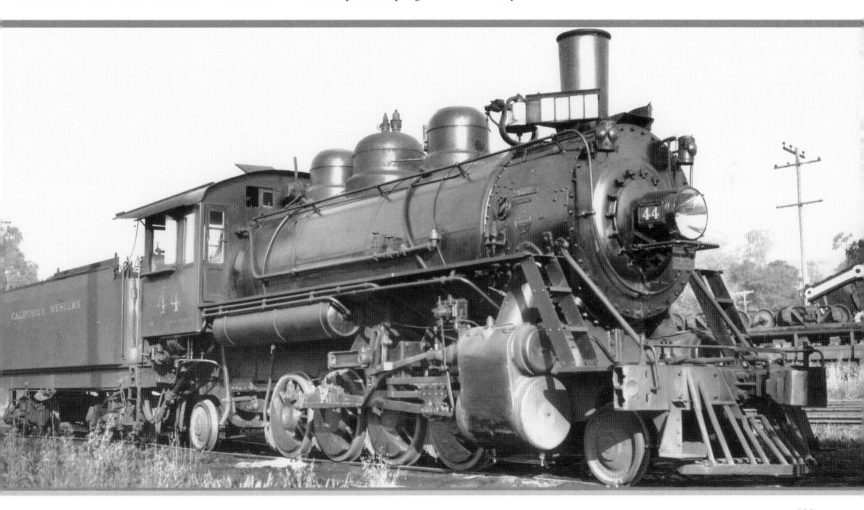

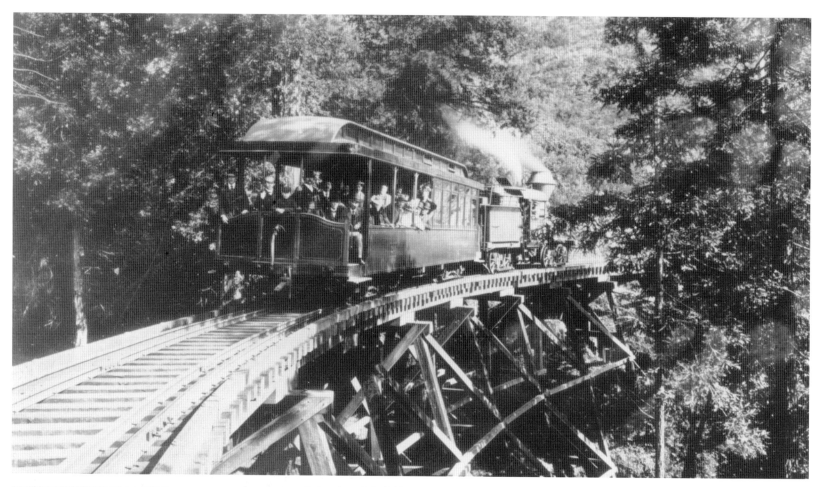

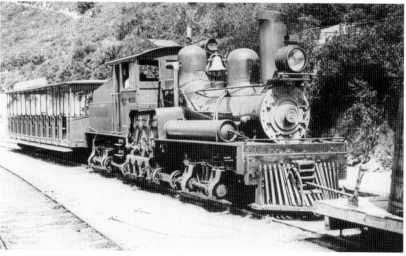

The Mount Tamalpais & Muir Woods Railway finished construction in August 1896, running from the NPC station in Mill Valley almost to the crest of Mount Tamalpais, with a branch into Muir Woods. In this 1902 view, MT&MW 2 Spot, a 30-ton Heisler, is pushing coach No. 20 over one of the road's numerous trestles. For safety reasons, the railroad's locomotives were always on the downhill ends of the trains. (Courtesy Trimble collection.)

MT&MW 7 Spot, a 37-ton Shay, was new when this 1908 photograph was made at the summit of Mount Tamalpais, 2,336 feet above sea level. On a clear day, one had a great view of much of California, making this standard-gauge railroad a popular tourist attraction until it was abandoned in 1930. (Courtesy Trimble collection.)

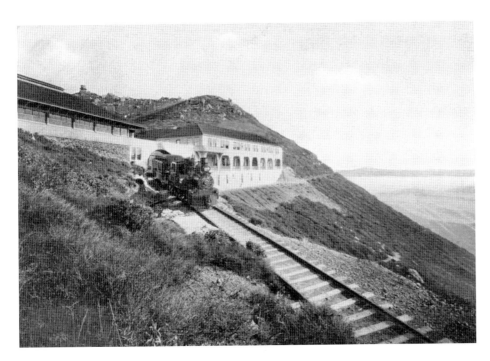

This postcard, mailed February 8, 1908, shows a MT&MW train leaving the tavern near the mountain's summit. By then, master mechanic Bill Thomas had converted the railroad's locomotives from wood burners to oil burners, saving fuel costs and at the same time reducing fire danger from sparks. (Courtesy Trimble collection.)

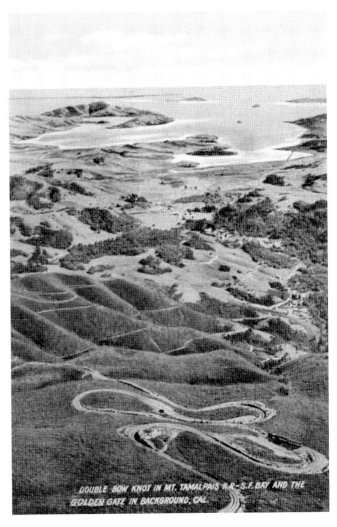

Double Bow Knot was named because of the track's loops, where the line paralleled itself five times to gain an elevation of a few hundred feet. The many curves assured that at no point would there be more than a seven percent grade, still quite steep for a railroad anywhere. About eight and a half miles long, the MT&MW was nicknamed "The Crookedest Railroad in the World." (Courtesy Trimble collection.)

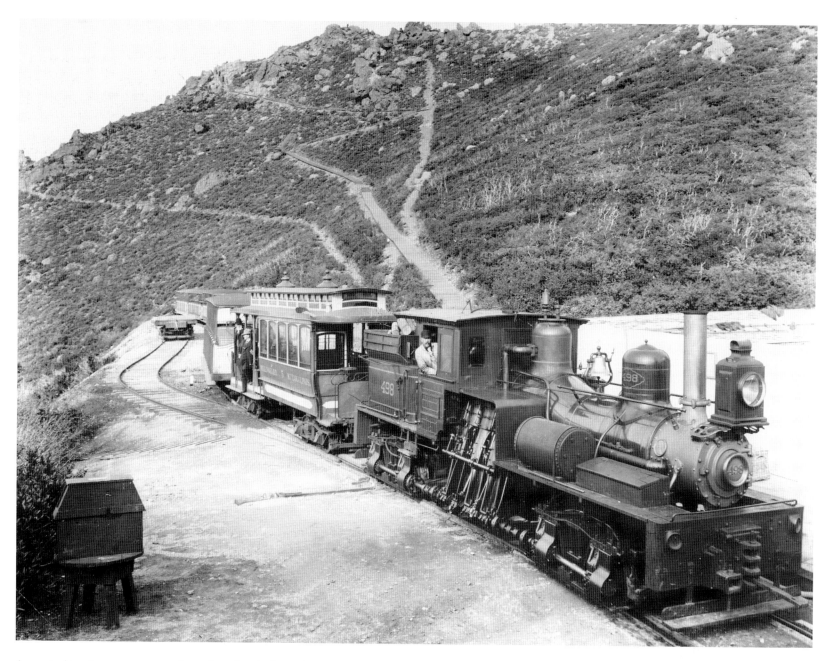

A mustachioed engineer peers from the cab window of Mount Tamalpais & Muir Woods Shay No. 498. Built by Lima Locomotives Works in 1896, it was the railroad's first locomotive and came to the mountain railroad from Usal Redwood Company and Dollar Lumber Company. In 1904, she was sold to the Terno Lumber Company. The coach in back of No. 498 is a cable car from the Omnibus Cable and Railway Company of San Francisco, built in 1893. (Courtesy Codoni collection.)

The Fairfax Incline Railway, pictured here, opened August 13, 1913, to promote sales of undeveloped real estate on Manor Hill. The incline was 1,500 feet long and rose to a height of 500 feet. Customers were charged 5¢ per ride. Perhaps the Redwood Empire's shortest passenger railroad, it closed in 1929. (Courtesy Trimble collection.)

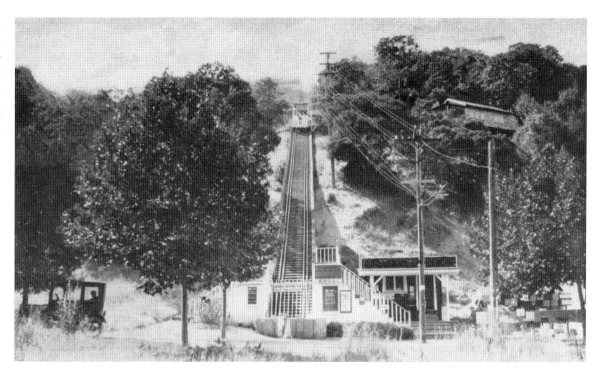

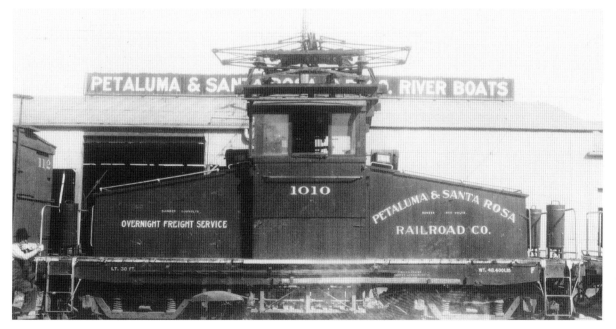

Petaluma & Santa Rosa Railroad 'juice hogs" did all the freight switching on the line until after World War II. In this photograph, No. 1010 is moving cars at the Petaluma dock. The locomotive advertises "Overnight Freight Service." (Courtesy Codoni collection.)

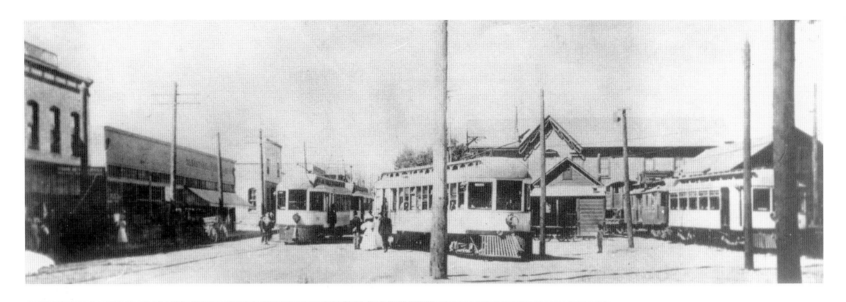

This much-copied company photograph shows the P&SR Sebastopol depot on Main Street in 1914. The cars' white livery later yielded to yellow because increasing number of motorists often mistook the interurbans for the many chicken coops in the "Egg Capital of the World," as Petaluma was called, and crashes were getting expensive. (Edward Fratini; courtesy Trimble collection.)

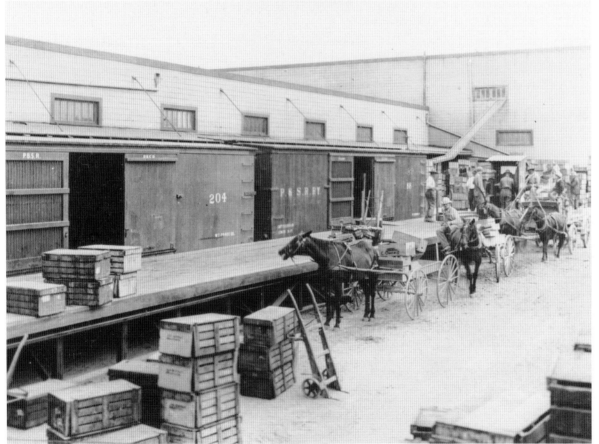

Farmers with horse-drawn rigs line up to ship their produce in the boxcars of the Petaluma & Santa Rosa Railroad. The man in the small shed at the right end of the platform is weighing the boxes, since shipping charges were based on weight. Note the ventilated doors on the railcars. (Courtesy Codoni collection.)

P&SR operated riverboats on the Petaluma River from Petaluma to San Francisco, connecting with its freight trains and interurbans, although passenger service ended in 1935. The steamers' cargoes ranged from chickens and eggs to farm equipment. *Gold I*, the P&SR's first boat, was lost in a 1920 fire. (Courtesy Trimble collection.)

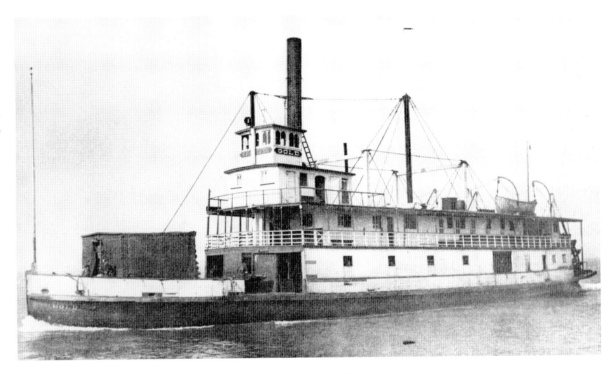

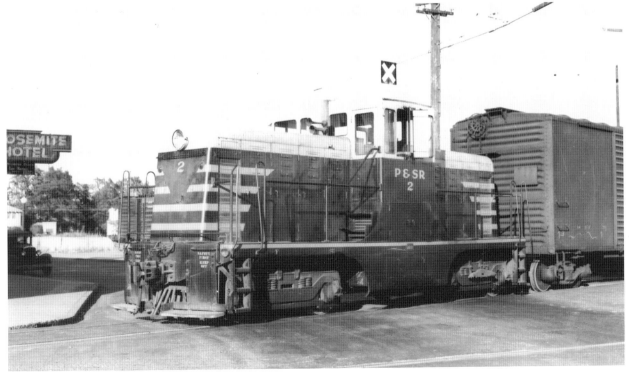

The NWP took ownership of the P&SR in 1932, making it a feeder to not only the NWP but parent Southern Pacific as well. In January 1947, the first of the General Electric 44-ton diesel locomotives arrived. Diesel No. 2 is pictured in Petaluma in 1948. (Courtesy Trimble collection.)

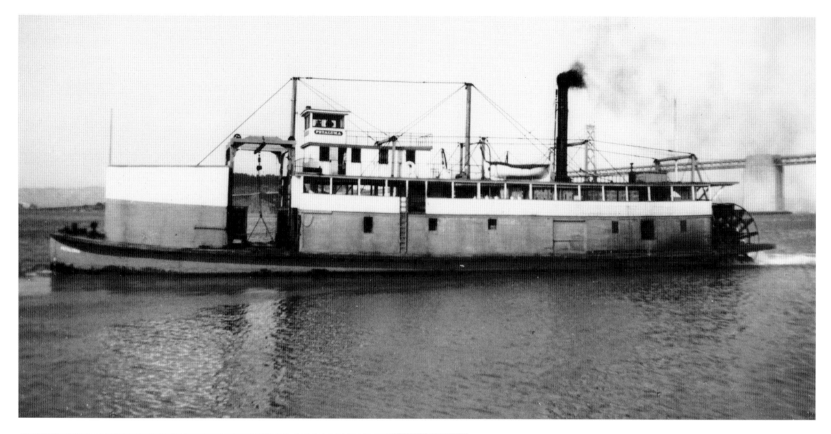

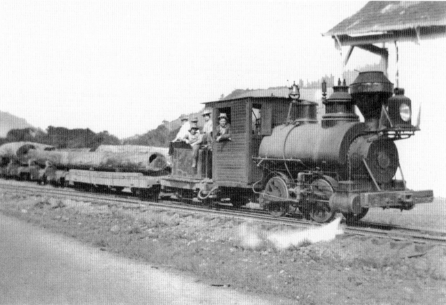

Petaluma II, the last of California's riverboats, chugs her paddlewheel across the San Francisco Bay to Petaluma. On August 24, 1950, Capt. Jack Urtin skippered her last run, ending another colorful era in Golden State transportation history. (Courtesy Trimble collection.)

Tyrone, an 1876 Baldwin product, worked for the Dollar Lumber Company at Markhams as well as at Tyrone Mills, where the locomotive undoubtedly got her name. This teakettle probably went to Duncan Mills Lumber and Land Company in 1885, and it is believed to have served there until 1917. (Courtesy NWPRRHS Archives.)

The Caspar, South Fork & Eastern, headquartered a few miles south of Fort Bragg, had no rail connection with the NWP. It did have a variety of steam engines, including a pair of 2-6-6-2s. Engine No. 5, pictured here, was named *Trojan*; sister No. 7 was *Samson*. (Courtesy Codoni collection.)

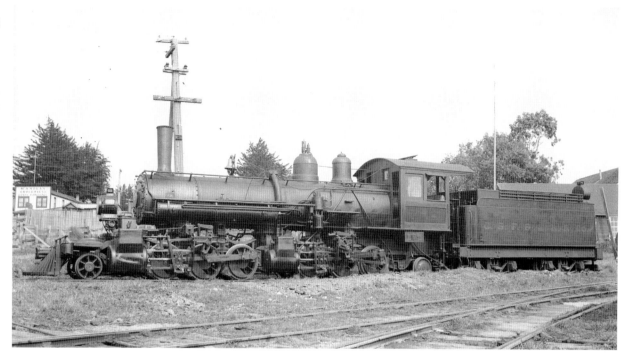

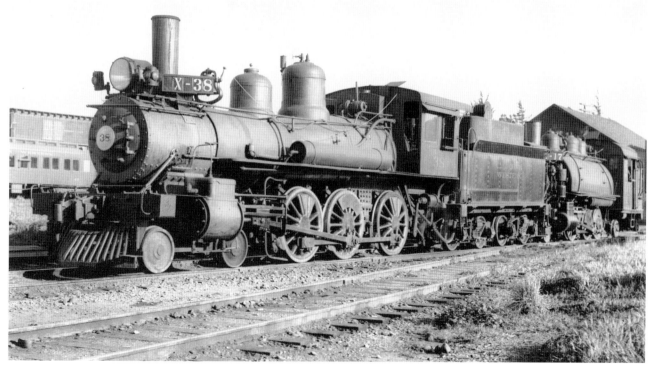

The Fort Bragg Railroad was started in 1885 by the Fort Bragg Lumber Company. The road became the California Western Railroad (CWR) in 1905 and reached Willits in December 1911. CWR No. 38, a 10 wheeler, and No. 17, a 2-6-2T, are on the Fort Bragg dead track in retirement in 1945. (Courtesy Trimble collection.)

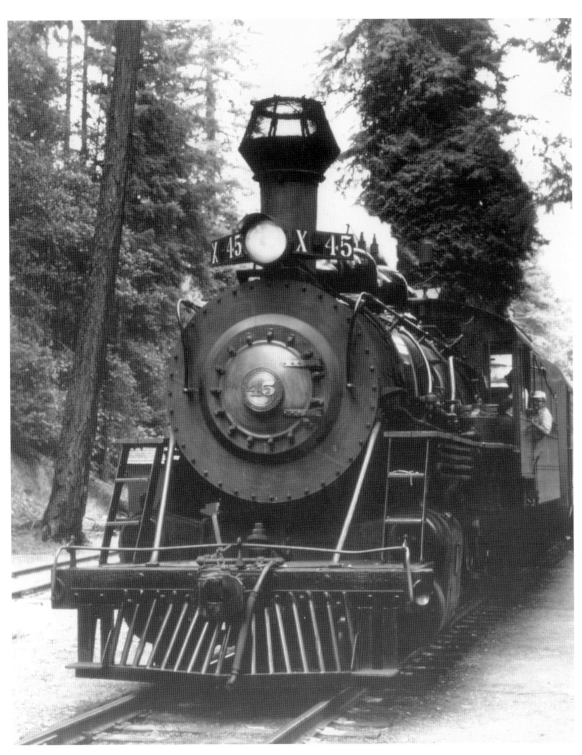

The popularity of the Cal Western, as railfans call it, is due not only to its nickname of "Skunk Railroad" but also to the scenery enjoyed by passengers traveling through Mendocino County's Noyo Canyon. Steam returned to CWR in 1964, when the railroad acquired No. 45 and put it into service as the "Super Skunk." (Company photograph; courtesy Trimble collection.)

For economic reasons, the California Western replaced steam passenger trains with rail motor buses in 1925. In the clean air of the Noyo Canyon, the internal combustion engines' fumes caused local residents to dub them "skunks." The name stuck, and today the CWR is called "The Skunk Railroad." (Courtesy Codoni collection.)

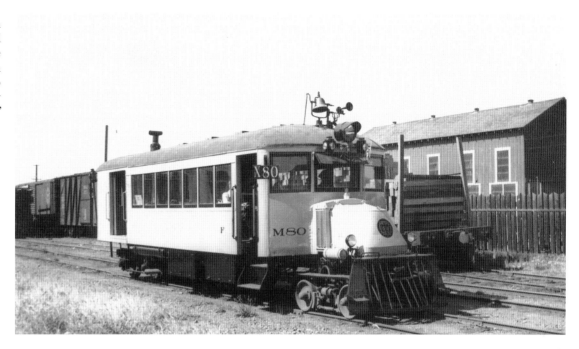

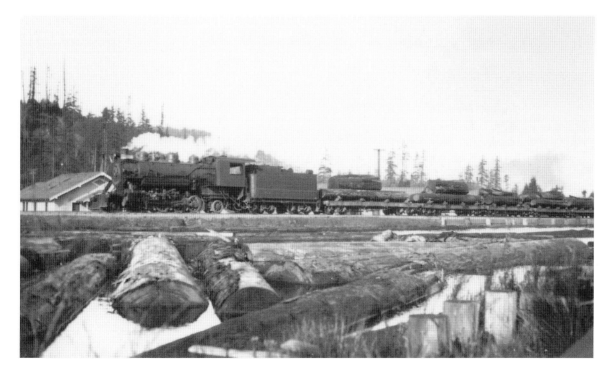

The 2-8-2 Mikado locomotive was as much a workhorse at The Pacific Lumber Company as on any mainline railroad. TPL No. 35, from Baldwin, hauls a trainload of logs past the log pond at Scotia in May 1930. (Courtesy Michael Fuller.)

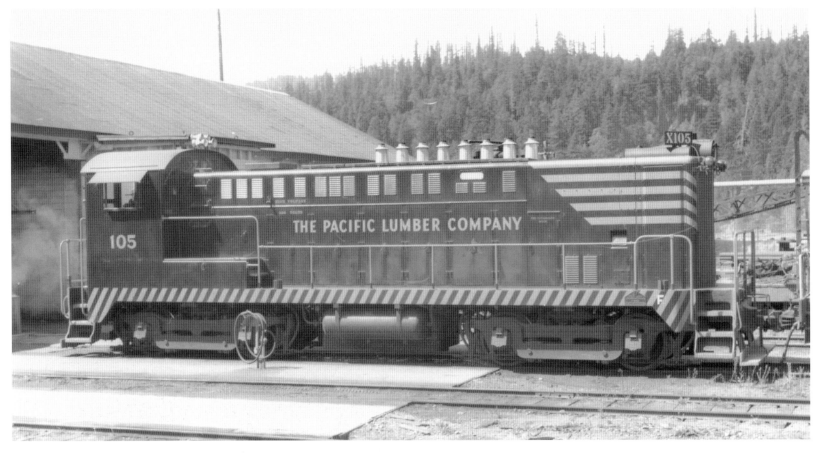

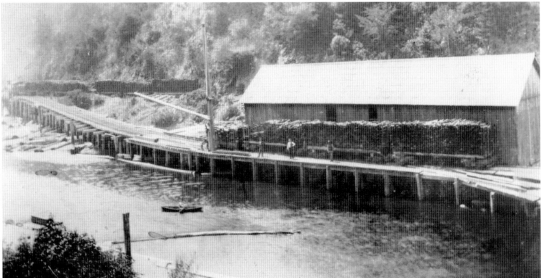

As with most American railroads, both main line and short line, conversion from steam to diesel meant an immediate reduction in fuel costs for the owners, and The Pacific Lumber Company of Scotia was no exception. The 1965 scene is in Scotia. (Courtesy Trimble collection.)

The Albion Lumber Company Railroad, running from Albion to Christine, didn't connect to the NWP, and all of its products, such as these carloads of tanbark in 1894, went out to sea at Albion. As the Albion's main line became the NWP's isolated Albion Branch in 1907, the branches and spurs remained lumber company property and therefore NWP feeders. (Courtesy NWPRRHS Archives.)

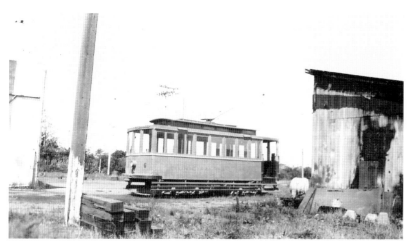

Eureka's 1888 horsecar system converted to electric streetcars in 1903 and continued until 1921, when the city took it over as the Eureka Municipal Railway. A chronic money loser, it was sold in 1940 to become a bus system, ending the NWP's only direct streetcar connection. (Courtesy NWPRRHS Archives.)

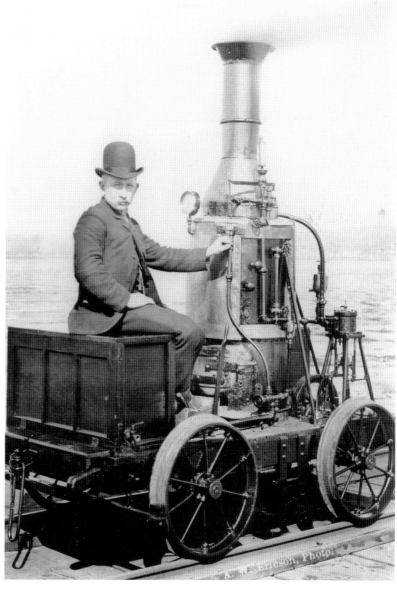

As picturesque as the old handcars may have been, they were somewhat slow and definitely dangerous for workers. This steam-powered speeder was more suitable for a brass hat on the Arcata & Mad River Railroad to inspect the line in 1902. (Courtesy Trimble collection.)

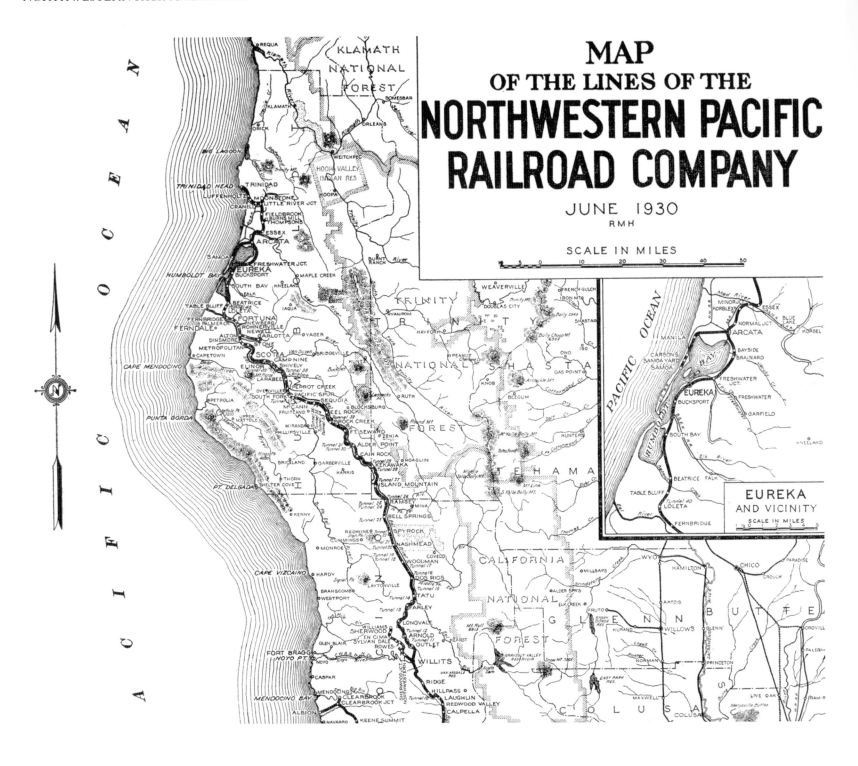

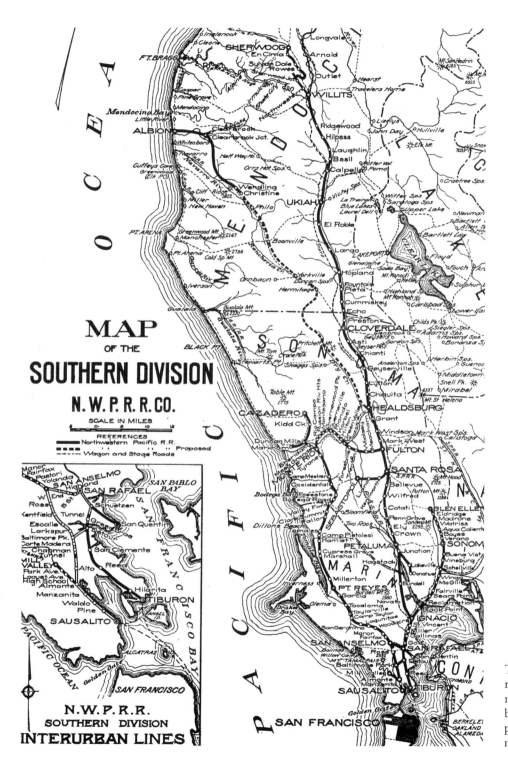

MAP
OF THE
SOUTHERN DIVISION
N.W.P.R.R.CO.
SCALE IN MILES
REFERENCES
━━━ Northwestern Pacific R.R.
▪▪▪▪ Proposed
--- Wagon and Stage Roads

N.W.P.R.R.
SOUTHERN DIVISION
INTERURBAN LINES

The main line of the Northwestern Pacific Railroad remained unchanged from the time of the closing of the north end gap to Shively in 1914 until the north end became the Eureka Southern in the 1980s. On these pages are the company maps showing the 1930 routes: the northern end (opposite page) and the southern end (right).

Across America, People are Discovering Something Wonderful. *Their Heritage.*

Arcadia Publishing is the leading local history publisher in the United States. With more than 3,000 titles in print and hundreds of new titles released every year, Arcadia has extensive specialized experience chronicling the history of communities and celebrating America's hidden stories, bringing to life the people, places, and events from the past. To discover the history of other communities across the nation, please visit:

www.arcadiapublishing.com

Customized search tools allow you to find regional history books about the town where you grew up, the cities where your friends and family live, the town where your parents met, or even that retirement spot you've been dreaming about.